WATERCOLOR FOR THE *fun* OF IT
How to Sketch with Watercolor

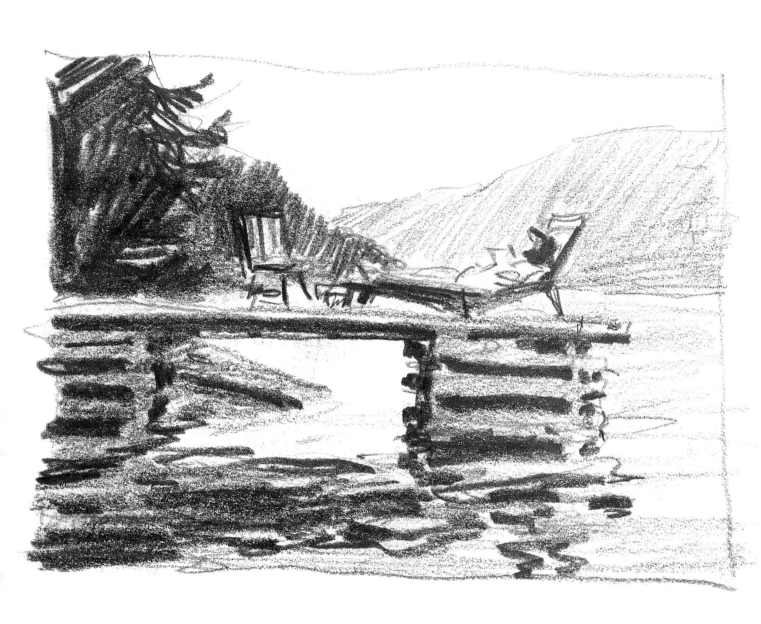

WATERCOLOR FOR THE *fun* OF IT

How to Sketch
with Watercolor

David R. Becker

NORTH LIGHT BOOKS
CINCINNATI, OHIO
www.artistsnetwork.com

About The Author

David R. Becker, MWS (Midwest Watercolor Society), works as an art instructor, fine artist and illustrator. The author of *Watercolor Composition Made Easy* (North Light Books), his work has appeared in *Splash 3* (North Light Books), *Watercolor in a Weekend* (David & Charles), *People in Watercolor* (Rockwell), *How to Make a Painting* (Watson and Guptill) and *American Artist* and *International Artist* magazines.

Becker has received numerous awards and is a signature member of watercolor societies across the nation. He feels his biggest accomplishment is instructing others in the art of painting so they can paint at their highest potentials. His workshops and classes are well attended due to his lively, fun ability to teach in a way that beginners understand and enjoy.

A native of Chicago, Becker has worked as an illustrator for the advertising agency Foote, Cone & Belding for twelve years and has taught at the Palette & Chisel Academy of Fine Arts in Chicago. The Ottinger Gallery in Chicago represents his work. He now resides in the Chicago suburb of Long Lake with his wife and three children.

Other fine North Light Books are available from your local bookstore or art supply store or direct from the publisher.

06 05 04 03 02 5 4 3 2 1

Library of Congress Cataloging-in-Publication Data

Becker, David R.
 Watercolor for the fun of it : how to sketch with watercolor / David R. Becker.
 p. cm.
 Includes index.
 ISBN 1-58180-233-1 (pbk. : alk. paper)
 1. Watercolor painting--Technique. 2. Drawing--Techniques. I. Title: How to sketch with watercolor. II. Title.

ND2420 .B45 2003
751.42'2--dc21

Editor: Amanda Metcalf
Page Layout Artist: Kelly Sohngen
Production Coordinator: Mark Griffin

METRIC CONVERSION CHART

to convert	to	multiply by
Inches	Centimeters	2.54
Centimeters	Inches	0.4
Feet	Centimeters	30.5
Centimeters	Feet	0.03
Yards	Meters	0.9
Meters	Yards	1.1
Sq. Inches	Sq. Centimeters	6.45
Sq. Centimeters	Sq. Inches	0.16
Sq. Feet	Sq. Meters	0.09
Sq. Meters	Sq. Feet	10.8
Sq. Yards	Sq. Meters	0.8
Sq. Meters	Sq. Yards	1.2
Pounds	Kilograms	0.45
Kilograms	Pounds	2.2
Ounces	Grams	28.3
Grams	Ounces	0.035

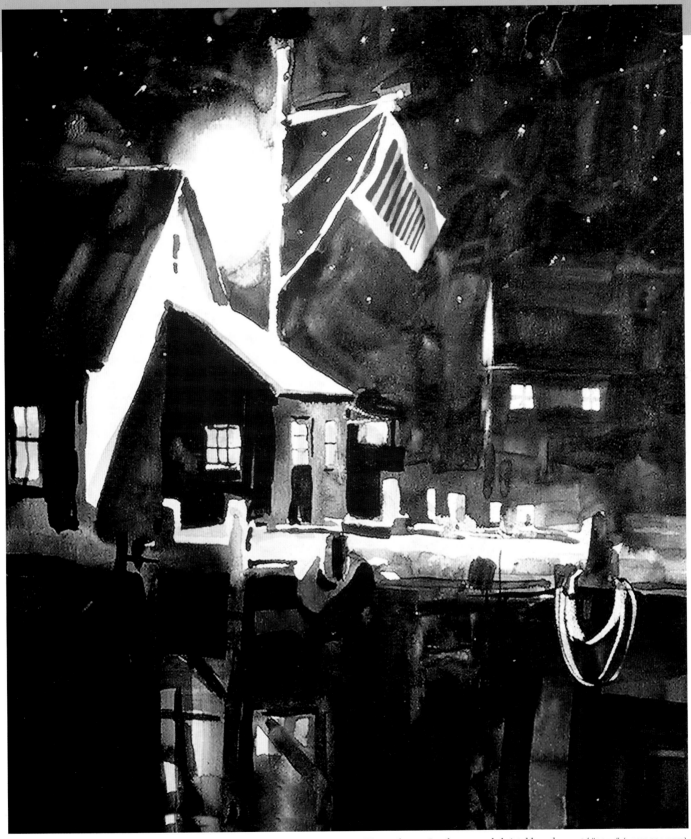

PORT CLYDE DOCK AT NIGHT • Watercolor on Strathmore 5-ply bristol board • 13½" × 12" (34cm × 30cm)

A Quick Start Guide

GLOSSARY OF TERMS

Block sheets of watercolor paper that are bound together at the edges

Bristol board durable sheet of paper made up of several plies of smooth paper

Clayboard museum-quality panel coated with absorbent clay

Cold-press paper with a surface with medium texture

Color scheme group of colors chosen to work together in a scene to achieve a particular mood or effect

Conté crayon hard, chalk-like crayon for drawing

Formal composition symmetrical design

Half-pans watercolor pigment in the form of small cubes that are hard and dry until softened with water

Hot-press paper with a slick surface

Informal composition asymmetrical design with visual balance

Negative painting painting around a shape with a contrasting value to define the shape's form

Pad sheets of watercolor paper bound together on one edge

Rough paper with a very rough surface

Sideline sketch sketch focusing on a part of a scene that needs special attention

Thumbnail sketch small sketch showing a scene's shapes and values without detail

Tubes watercolor pigment in liquid form

Value sketch black-and-white or color sketch using shade or tone to show a scene's range of lights and darks

Viewfinder any object, such as a slide sleeve or camera, that frames a scene to help establish composition

Watercolor board watercolor paper mounted to a heavy, 40-ply board

Watercolor sketch thorough sketch done in watercolor that takes the painter through the design, value and color scheme of a scene and that acts as a blueprint for a larger, more finished work of art; also called a study

Wet-in-dry technique of applying a very wet, saturated brush to a dry surface

Wet-in-wet technique of applying paint to a wet surface

People frequently ask, and I believe many others wonder, "How did the art masters become so skilled, and what path of learning did they follow to get to such a professional level?" Many think there is an exact learning process—a kind of formula, a shortcut or a secret way of working they need to uncover or learn—to reach that level. The truth of the matter is that the way to become a skilled artist is quite simple: Practice often. Practicing sounds simple enough, but practice itself requires work and dedication.

For artists, inventors, painters, composers and other creators, the creative process starts simply when an idea pops into one's head. Most creators then sketch the idea very roughly on paper. The beginning of a great idea could take form on something as basic as a restaurant napkin. After drawing a few thumbnails and focusing the idea, the creator draws it again, this time in the form of a more mechanical drawing, such as an artist's value sketch. It illustrates all of the thoughts and parts that will make the idea work. From this final sketch, a finished product will be executed. An artist paints a final painting. An inventor creates a prototype. A composer scores a symphony. In any of these cases, sketches are necessary and important stages in the development of a finished work.

Many beginners want to bypass the sketching stage, opting for the faster approach of copying photographs. This approach will work if the photo has good color, a good value pattern and a composition that works. Even then, Mother Nature was a master herself, and trying to imitate her talents in color mixing and composition can be very frustrating. If the photo doesn't have good color, value pattern and composition, you'll have to change the photo's elements. The place and time for that is the sketching stage, not while adding the final details of a studio painting. This is especially true in watercolor, which doesn't often give you a second chance. It's difficult, sometimes impossible, to scrub off or paint over an area you want to change or correct. Planning ahead allows you to practice and get all of your mistakes out of the way.

Tip Practice is the secret to becoming a master. Practice sketching whenever you have a spare minute, anytime, anywhere. Also use sketches to practice for each of your paintings. Start with a thumbnail of your basic vision. Move on to a more mechanical sketch, such as a value sketch, and then use what you've learned to work on your final painting. The practice and the planning will do amazing things for you.

Black-and-White Sketching Materials

All you need to start down the path to becoming a skilled artist are an eraser, a no. 2 pencil and a piece of white drawing paper. You probably already have these supplies at home. In fact, you really don't need any fancy art supplies to become a skilled draftsman. What you need is a lesson plan and practice. The lesson plan starts on the next page. The practice part is up to you!

Watercolor Sketching Materials

You'll need a no. 12 or no. 14 round watercolor brush; a small sheet of watercolor paper, a watercolor block or a watercolor sketchbook; a container of water; a palette for color mixing (a white paper plate works fine); and three tubes or cakes of watercolor—dark blue (maybe Pthalo Blue or Prussian Blue), red or magenta (perhaps Alizarin Crimson) and yellow (possibly Yellow Ochre or Quinacridone Gold). Use any version of each of the primary colors, but make sure you use dark colors so you can get a wide range of values between the pure pigment and white.

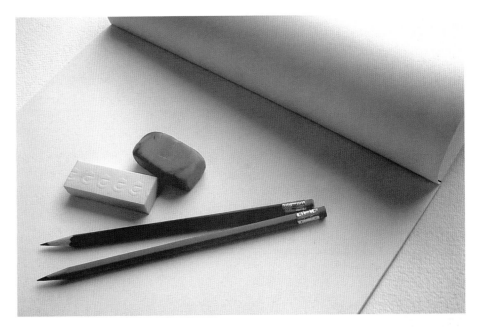

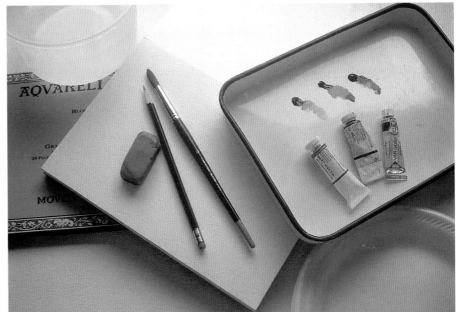

Tip You don't need fancy art supplies to become a skilled sketcher.

You Can Sketch Anywhere…

Manufacturers sell many products that make it easy to sketch and paint on the go. I converted a small oil painting box into a watercolor sketch box. It holds everything I need to sit down and quickly whip out a sketch. Make whatever you use small, efficient, quick and, most importantly, easy to set up anywhere. Remember, you're setting up to sketch, not to paint a masterpiece.

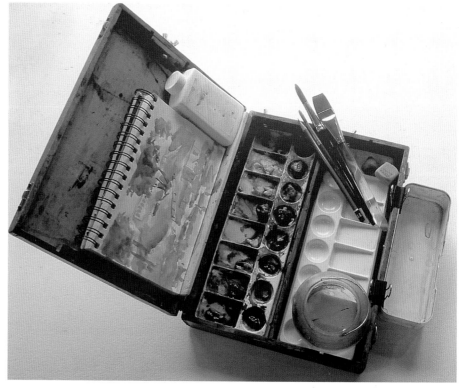

You can paint most anywhere with a simple setup. I use my sketch box on my commute to work, which is a great opportunity to practice and sketch small pieces to use later for larger, finished works of art.

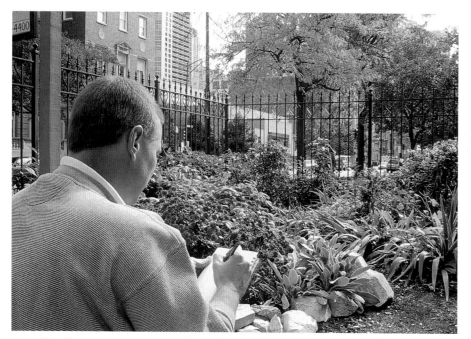

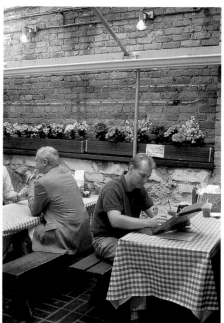

A small, well-organized sketch box enables you to sketch in locations you never would have thought of. Here are some places I sketch. Take some time to think of a few places or opportunities that would give you extra time for practicing and sketching.

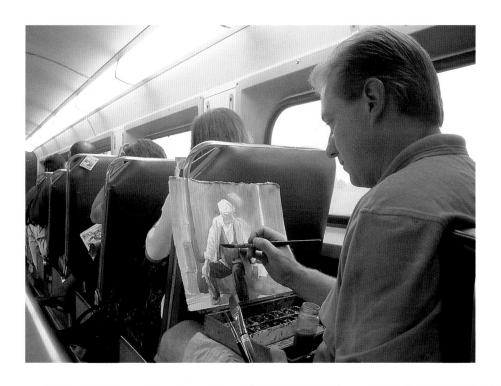

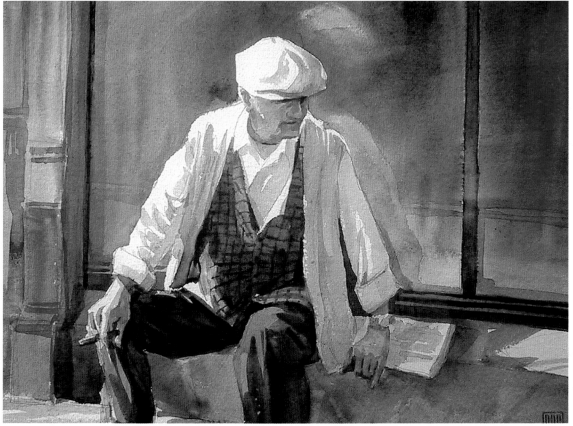

MAN ON GRAND • Watercolor on Arches 300-lb. (640gsm) rough • 11" × 14" (28cm × 36cm)

...Anytime...

Any time is a good time to sketch. If you're commuting on public transportation or waiting in a doctor's office or if you have half an hour for lunch, take advantage of these extra moments.

You can do quite a bit of sketching in as little as fifteen minutes. For this exercise, pack up your sketching materials and take them with you wherever you go. If you don't have enough room to carry a small watercolor set, take a pencil, a small sketchbook and an eraser.

Study the photos below. Don't sketch them now; just take five to fifteen minutes to memorize the large shapes and large value patterns. Sometime during the day when you have a few minutes, try sketching the scenes from memory. Don't attempt tight sketches. Focus more on the pattern and objects in each scene. Try to remember the center of interest and how all the large value patterns affect it. Don't spend a lot of time noodling it. Instead, do a couple quick sketches. If you just can't remember what

you saw in the photos, draw anything you want so long as you're sketching. Next time you have the book, study the photos again. Keep working your mind-eye memory.

Repeat this exercise with different images whenever you have a moment. After a week or two, you'll be surprised at how differently you look at subjects and how easy it is to pick out the big pattern. You essentially will have trained your mind to see as an artist sees, rather than how the average person does.

Squint your eyes as you study these photos. Squinting helps block out the colors and the detail, giving you a look at the black-and-white value pattern. Memorize the value patterns as best you can. Then sketch each scene from memory. Don't worry about putting in detail. Sketch the big picture, the large value pattern.

Tip Train your mind to understand the picture and your hands to draw what your mind sees.

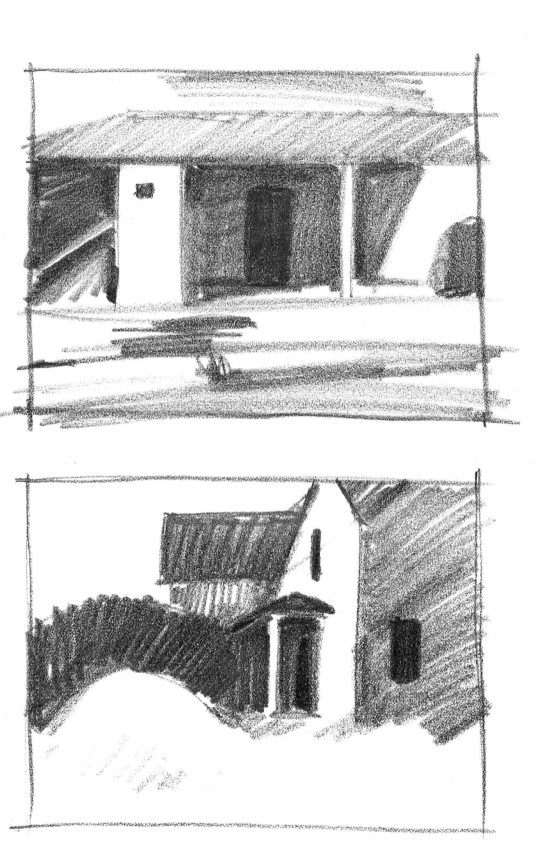

These two thumbnail sketches were my attempts at this exercise. I admit that I had an advantage because I shot the photos, and I know these particular subjects well, so don't get discouraged if your sketches aren't as accurate as mine.

...Any Way

No matter how or where you're sketching, the procedure and supplies you use should be the same. If possible, use the same types of brushes, paper and paints in each place you sketch. The only difference should be your location. You could spend all of your time figuring out how each brush, paper or paint handles. It's OK to practice and test many different types of materials and tools, but don't get caught up in thinking that a new brush, a different tube of paint or a certain sheet of paper is going to make you a better artist. What makes you better is practice and experience. Then, the fundamentals of sketching will come to you subconsciously, just as a musician doesn't think about individual notes after a long time practicing scales.

Pencil sketches, value sketches and watercolor sketches all are forms of practice and ways to establish composition. How you sketch is not as important as what sketching teaches you. It gives you the ability to plan out and run through the same procedure you will follow in your finished work of art.

The style or technique you use to do your sketches will develop on its own. The artists whose sketches appear here have different sketching styles, but they all use sketching as a way to practice and form a plan of attack for the finished painting.

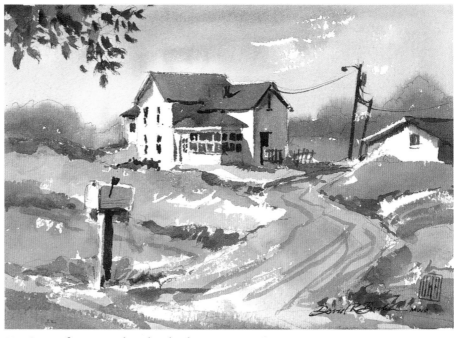

Here is one of my watercolor value sketches.

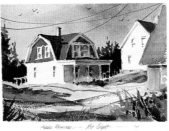

Robert Wade paints his sketches plein air on a single sheet of paper divided into quarters.

Tip Try to use the same materials wherever you're sketching— outdoors, on a bus, in your studio. Don't get caught up in your brushes and paints. When sketching, just concentrate on the scene and your technique.

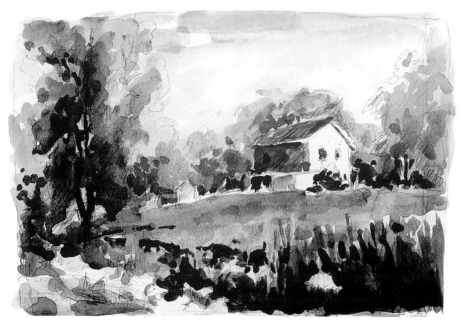

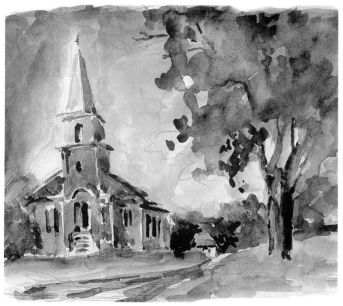

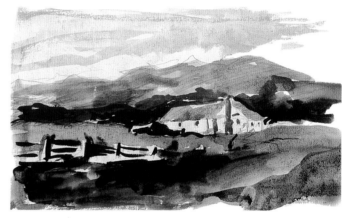

Alena Pokorna does her sketches in a plain paper sketchbook. She adds watercolor to plan the colors she'll use in her finished painting even though her sketchbook is not made of watercolor paper.

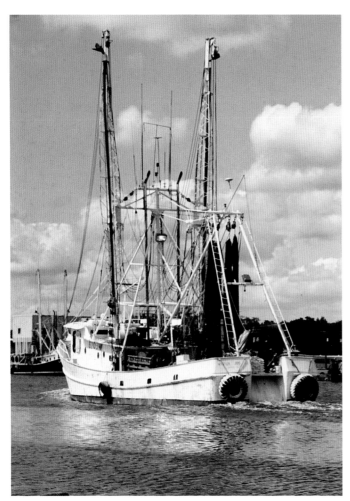

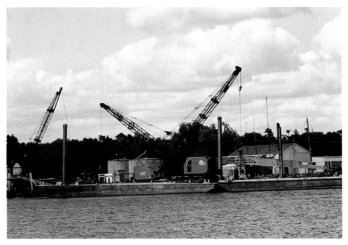

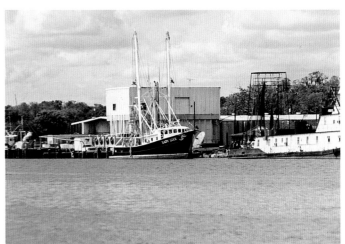

Keith Raub combined elements from these reference photos to draw the
pencil sketch on the next page.

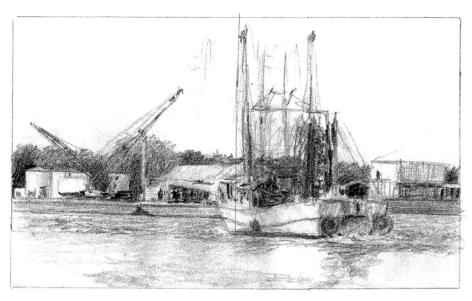

Keith used the photos on page 18 and this sketch to paint the watercolor painting below.

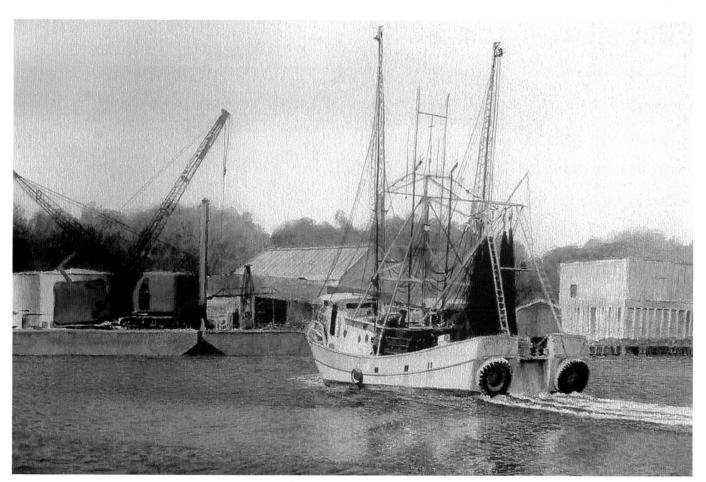

LOUISIANA BAYOU • Watercolor on Arches 300-lb. (640gsm) cold-press • 12⁷/₈" × 20¹/₂" (33cm × 52cm) • L. Keith Raub

Seeing the Big Picture, Angles and Shapes

Find a place to sketch, somewhere you can spend half an hour to an hour without interruptions. Good lighting isn't a big issue at this point. Just make sure you have enough light to see a wide range of values. This exercise will help you recognize the basic value pattern in a complicated, full-color scene.

Tip Don't just copy a scene. Make the composition and, as we'll discuss later, the color scheme of your sketch better than your reference, whether it's a photo or the actual scene in front of you.

I chose this photo of the Cuneo Museum because the scene already has a good composition; none of the large masses need to be changed. When you begin to sketch, concentrate your efforts on values—lights and darks—and drawing. Even though this picture has a good design, don't copy it exactly. Try making your value sketch better than the reference photo. That's what makes you an artist.

Make black-and-white copies of your own color reference photos when sketching scenes for your paintings. A black-and-white image offers a better look at the large masses in a painting, eliminating unnecessary details you don't need until the final stages of a painting. At that point, you can return to the original color photo.

Draw Large Angles

1 Draw a border or frame no bigger than six or seven inches (15 or 18cm) wide. Begin lightly penciling in the large angles that make up the shapes of the scene. Don't include details at this point. Just work out the large masses. The purpose of this and any other sketch is to remove detail to see the more important elements more clearly. Make your lines lighter than these. I made mine darker than usual so you could see them clearly.

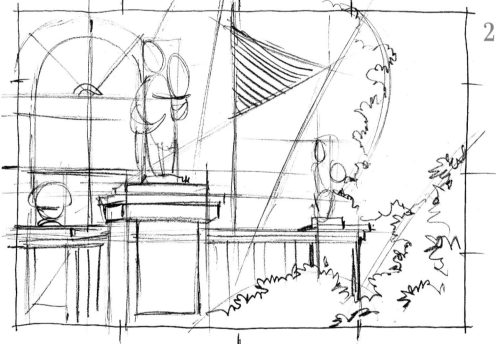

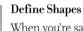

Define Shapes

2 When you're satisfied with the composition of your sketch, go over your lightly sketched lines with a darker stroke. The line work now should establish more exactly the contours of objects. Again, don't worry about detail until you get to the actual painting.

3 Shade Light Areas

Shade in the largest light and medium value masses. As you shade, think of your sketch as a watercolor painting. Go through the same steps you would for a painting.

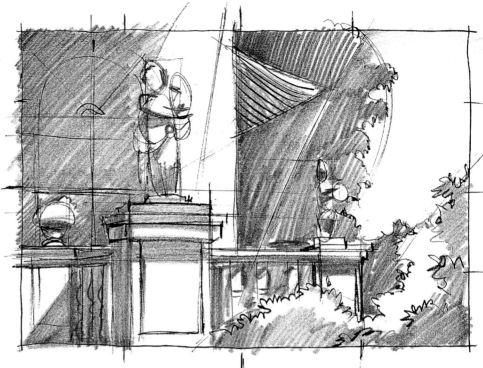

4 Put In Darks

Put in the large darks to give the sketch more depth. The picture should start to come together in this step. When you add the dark masses, try to keep the edges clean.

Tip When shading large areas with a pencil, make sure there is a lot of lead showing on your pencil. It doesn't need to be sharp because you'll be using the broad side of the lead and not the point. Start with the lighter areas and progress to the medium areas.

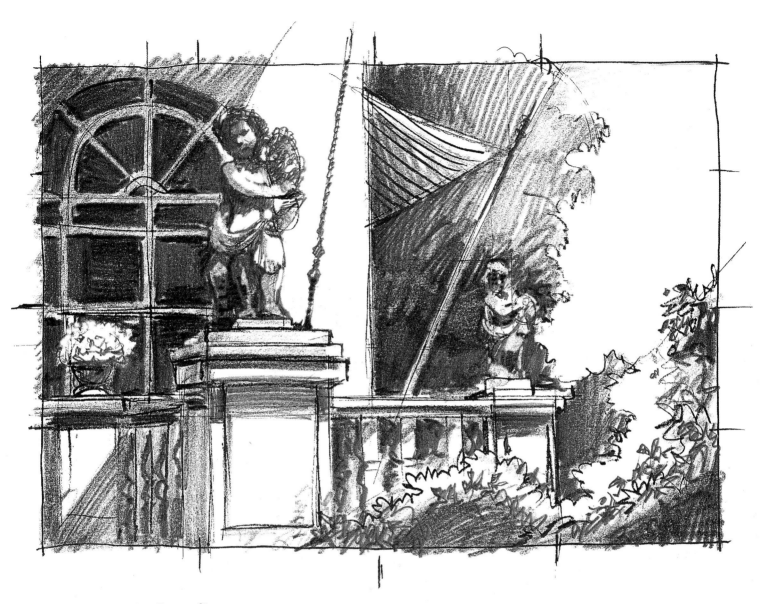

Add Details Near Center of Interest

5 To finish the sketch, add detail to the main center of interest—the sculpture and the area around it, including some of the foreground. Don't overwork the sketch. It's not meant to be a finished work of art. Rather, it's a blueprint and a run-through for the final work of art.

Seeing Color

For some artists, a black-and-white sketch is enough to guide them through a finished painting. Others need to figure out the color scheme before continuing.

1 | Draw Line Drawing

Draw a line drawing on watercolor paper based on the sketch you drew in the previous mini demo.

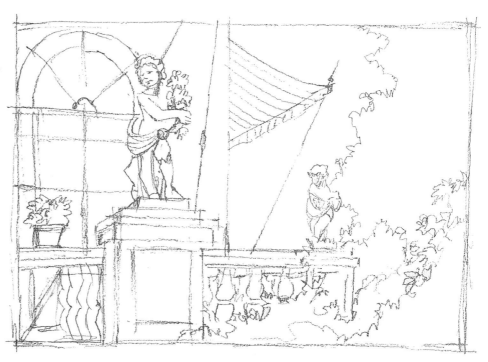

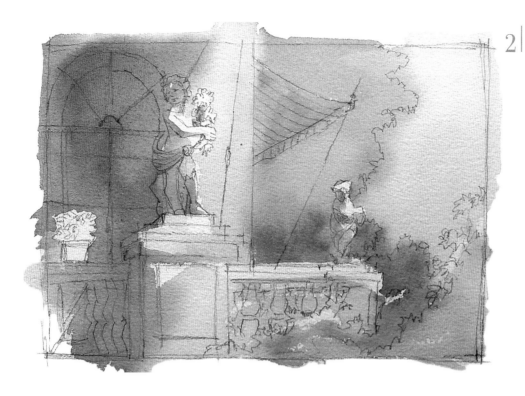

2 **Paint Light Areas**

Work a light wash into the largest areas of light value. Watercolor painters usually work from background to foreground and light to dark. There will be many instances, as in this exercise, though, in which the subject matter does not have great distance or aerial perspective. In these cases, start with the background or the middle ground (the building is the middle ground in this scene). Also establish your darkest dark as soon as possible so you can compare it to the light areas you've just laid down and determine the other values in between. Don't worry too much about what colors to use at this point. Worry more about the values and edges. Put cooler, muted colors in the background and warmer, more vibrant colors in the foreground.

3 **Paint Midtones**

Work the large midtones in.

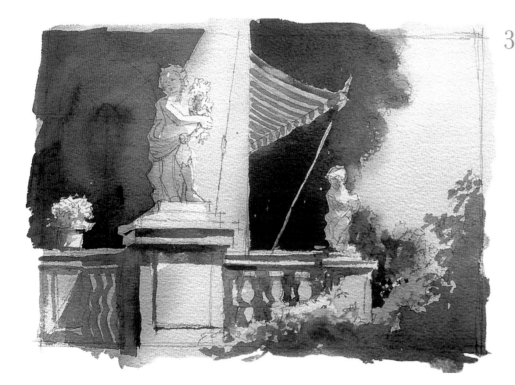

4 | Paint Darks

Paint in the darks, using them to cut around lighter objects to give shape to the scene.

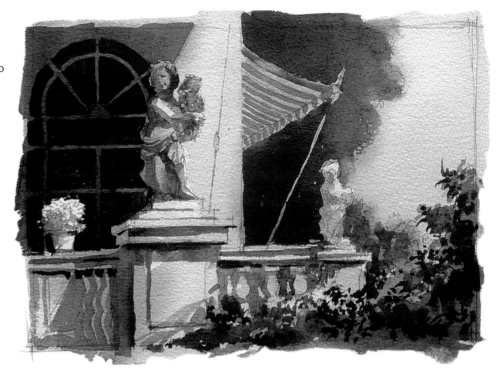

5 | Work In Details

Now you can put in the detail. Work most of your detail into the center of interest—the area you want the viewer to look at the most. Remember that this work is meant to be a sketch, not a finished work of art. This sketch will help you complete an actual painting.

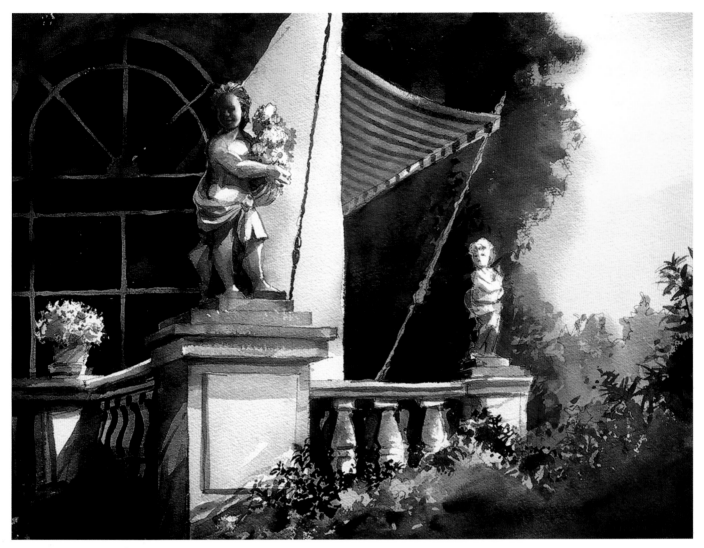

6 Base Painting on Sketch

I used the sketch on page 26 to work out the colors and values for this painting. For the painting, follow the same steps you followed to do the sketch, this time working with a full-color palette. Also work larger and keep things cleaner. If you made mistakes while working out the sketch, keep them in mind and try to avoid them while working on the finished painting.

Cuneo Mansion • Watercolor on Arches 300-lb. (640gsm) rough • 15" × 20" (38cm × 51cm)

Tip Any mistakes you make during a sketch can lead to a better finished painting. If you made a mistake laying paint down or don't like a color choice, use that knowledge to get better results later.

1 sketching MATERIALS

If you are anything like me when it comes to being an artist, you must love visiting art supply stores and purchasing new supplies. It's a wonderful feeling to pick out new brushes, try new colors or get that new set of colors that comes with its own paint box. The only part I don't enjoy is the cost. Unfortunately, creating tomorrow's art with these materials is what the craft is all about. In this chapter, I'll lightly brush over the materials you'll need for pencil value sketches, color value sketches, sideline sketches and sketching in general. These materials will help you get the job done right and simply.

Here are my studio and all of the supplies I've collected over the years. When I'm sketching and painting, though, I really only need the items on my drawing table.

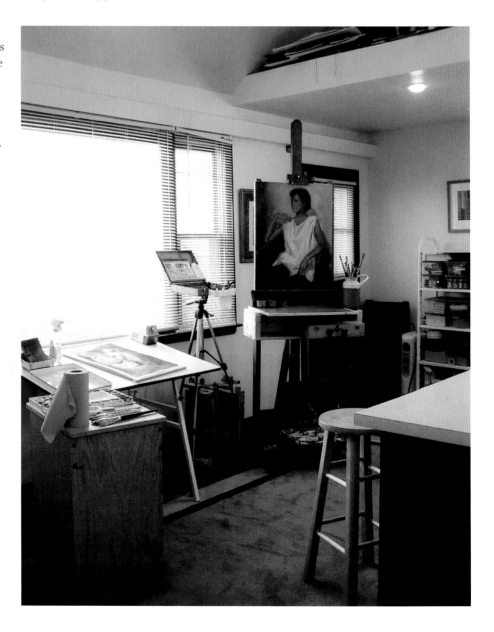

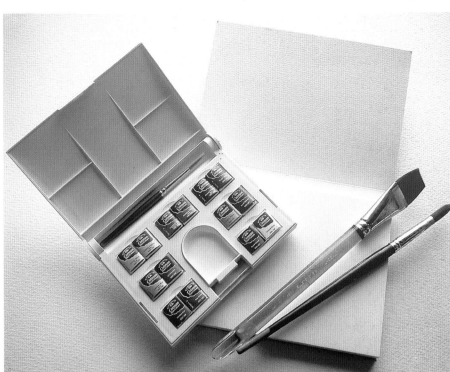

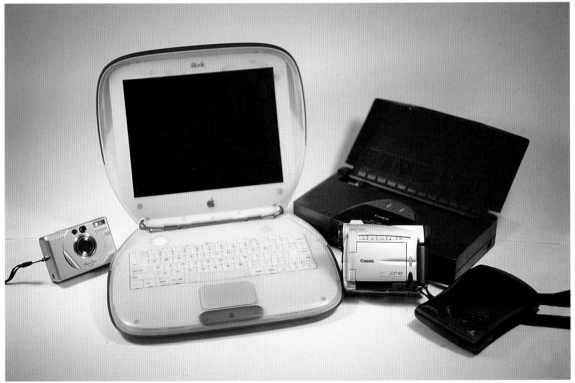

Paper

Any paper will do if you're sketching with just a pencil and an eraser. The paper just needs to take a soft pencil easily and shouldn't be too coarse. Start a sketchbook. If you prefer loose papers, keep them in a binder so they'll stay together and protected. This way you can review your progress easily.

For pencil sketches, use plain sketching paper or smooth watercolor paper. Many manufacturers now make sketchbooks of watercolor paper. For watercolor sketches, use a sheet of watercolor paper or a treated surface. I use Arches watercolor paper, Strathmore bristol board, Crescent watercolor board and Clayboard. Most of these are available in single sheets, blocks or pads.

Watercolor paper comes in weights of 90-lb. (190gsm), 140-lb. (300gsm), 260-lb. (550gsm), 300-lb. (640gsm) and up and comes in three textures: hot-press, which is similar to bristol board with a slick, smooth surface; cold-press, which has a bit of a tooth; and rough, which is, as the name states, roughly textured. Bristol board comes in plies, such as 1-ply, 2-ply, 3-ply and up. The larger the number, the thicker the paper. All of these surfaces are fine for sketching. Experiment with as many different papers as possible. It helps you learn how each paper handles. After you settle on the kind of paper you like, though, use it wherever you paint or sketch so you can concentrate on your painting and not on your paper.

Stretch thin paper, such as 90-lb. (190gsm) or a 140-lb. (300gsm) sheets, by soaking it in water for a few minutes. Then staple it to a board to keep it stretched and let it dry before painting. Don't worry about stretching small sheets. Just tape them to something rigid.

Art supply manufacturers also stack sheets of paper together and seal all four edges with plastic to form blocks of paper. Wipe the surface with a damp sponge before sketching. This prepares the surface by removing the sizing, a glue-like substance that holds the fibers of the paper together. The paint can penetrate the paper once the sizing is removed. Don't use these blocks for larger, finished works of art; you'd have to stretch the thin paper to keep it from wrinkling when you apply washes.

Pads are sealed only on one side. These sheets of paper usually are 140-lb. (300gsm) and need to be stretched if larger than 8" x 10" (20cm x 25cm). You also can clip sheets of 300-lb. (640gsm) paper together to make your own pads.

A sketchbook is a must for any artist, beginner or advanced. It's a diary of your progress, and its entries should be blueprints for anything you paint. What the sketchbook looks like doesn't matter as much as what you put into it.

Pads of paper are OK for sketching, but I don't recommend them for large finished paintings.

Tip When working out a sketch, the paper you use isn't important. When doing a finished work of art, though, use a heavy, quality paper. You get what you pay for.

These are just a few of the papers available to artists. When searching for the kind of paper that suits you, try trial sizes. Do small sketches on different papers. Sketch on them until you feel comfortable with a paper that works well for you. If you don't test and practice on paper that is new to you before working on actual paintings, be prepared for frustration.

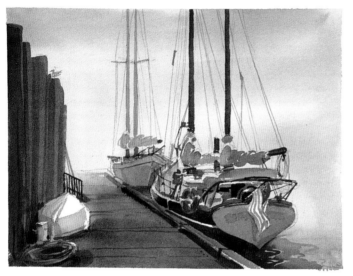

These sketches show the different effects of different kinds of paper. I did this sketch on Arches 300-lb. (640gsm) rough watercolor paper, which lets pigment soak in.

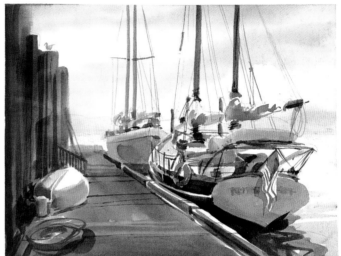

I did this sketch on Strathmore 5-ply bristol board, which is very smooth. The pigment sits on top of this paper rather than soaking in.

Tip Work your sketches on a small sheet of paper or a sketchpad instead of a large sheet of expensive paper. You'll loosen up more and be less afraid of making mistakes if you don't have to think about the cost of the paper. Use a good, thick paper for your finished works of art, though. Watercolor painting has enough obstacles without cheap paper.

Pencil

Pencils, Conté crayon, pastels, charcoal and pen and ink are all great sketching instruments. When sketching, though, make sure you use a drawing instrument that lets you apply a wide range of values from a very dark dark to a very light light.

When working out a value sketch, use a soft pencil, Conté crayon or anything that can make hard and soft lines and a dark dark. If you sketch with pencil and then apply watercolor, use a harder pencil that will not leave as much graphite on the painting surface. Too much graphite will dirty up your colors. Woodless graphite pencils, which come in HB and up, can leave too much graphite if you're using a version that is too soft.

You can use a Conté crayon the same way you'd use a pencil, but it's a little harder to erase. Prismacolor Black pencils are the blackest black you can get, but they're nonerasable, so don't use it for line work over which you'll paint a final painting. Use it just for sketching. Watercolor pencils allow you to add water after doing the line drawing and shading. This is especially useful for getting a good look at the large value pattern in your sketch. Pen and ink and markers offer good blacks but are nonerasable. Both will bleed if you add water.

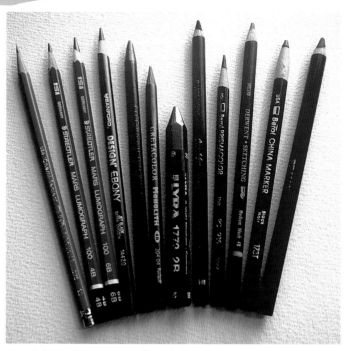

From left to right are 2B, 4B, 6B and Ebony lead pencils, woodless graphite pencils, a Conté crayon, a Conté crayon pencil, a Prismacolor Black pencil, a watercolor pencil, a china marker and a large wood and lead pencil.

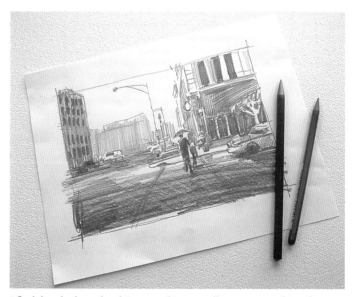

I find that the best sketching pencil is a woodless, pure graphite, 6B pencil. But don't use it for a base line drawing for a final painting on watercolor paper. It's too soft and will leave too much graphite on rough paper. This value sketch was done on a piece of ordinary copy machine paper using a woodless graphite pencil.

Paint

Watercolors come in tubes and half-pans, or cakes. Tube paints come out of the tube already wet. Half-pans usually come in a tray and need to have water added. Dye watercolors are less popular and used mostly for airbrush illustration.

Tube paints and half-pans differ in the ways you use them. For a moment, think of paint as sand instead of pigment. If you add a wet, gooey substance to the sand, it holds together, like tube paint. Adding water to this gooey sand makes it spread, as tube paints do when applied to paper with water. But if you let the gooey sand dry hard, it becomes more difficult to loosen until you add water, like half-pans.

You have to loosen half-pans with water to load your brush with enough pigment for a wash. Beware that after you apply the pigment to your surface and the water evaporates, the value will look about 20 percent lighter.

So which watercolors should you buy? Any watercolor is fine as long as you know what the differences are. Student grades have less pigment and more gooey filler. Certain colors last longer than others. Research the permanency and lightfastness of paints in each manufacturer's brochure.

Adjust the way you work to the pigment you're using. When using student-grade paint, use more pigment to get a rich color and a vibrant wash. When working with half-pans, make sure the cakes are soft so you can pick up a lot of pigment. If you're painting with a tube of high-quality professional paint, you won't need as much pigment to get a vibrant color, and because it has less filler, the paint won't dry as fast or as hard as lower-quality paints. No matter what paints you use, be sure to test them and experiment before painting a finished work of art.

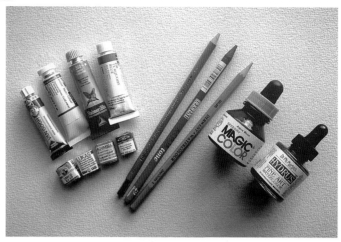

The two most common forms of watercolor are tubes and half-pans, at left. At right are watercolor dyes and solid woodless watercolor pencils.

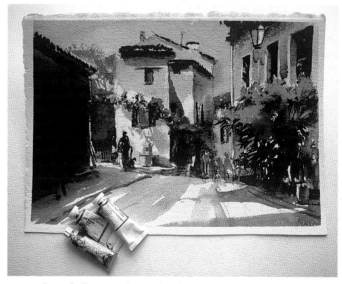

I steer clear of telling people exactly what colors they should use. With so many wonderful colors on the market, I don't want to limit anybody to my preferences. Just use the primary colors when sketching, though. If you want a few more colors, grab a light and dark each of blue, red, orange, yellow (or another earth tone) and green (normally I mix my dark greens). Keep it simple at first. You can always branch out to more colors later.

Brushes

After years of meeting watercolor artists, I have noticed that many have a large collection of brushes rolled up in canvas brush holders or sitting in coffee cans. If I were to ask these artists how many of those brushes they actually use on a single painting, they'd probably answer just three to five of them.

A watercolorist only needs about three brushes: a 1-inch (25mm) flat, a no. 12 round and a no. 3 or 4 rigger, also known as a script brush. The only other brush you may want is a 1¹/₂-inch (38mm) flat for painting large washes, such as skies.

My nonscientific analysis has found nylon brushes to be very consistent in the way they handle. They come to as fine a point as the more expensive animal-hair brushes. Nylon brushes do wear out faster then high-quality hair brushes, but I can buy about five nylon brushes for the price of one good hair brush. White nylon and golden nylon brushes both work well. I do sometimes use animal-hair brushes as well. If you're going to buy one, you might as well make sure it's high quality.

Use the same brushes for sketching both in and away from the studio as you would for your finished paintings. The secret to experience is consistency: using the same brushes over and over, until you know exactly how to handle them. Don't use the small brushes that come with tiny sketch sets. Instead, learn to use your standard brushes on both sketches and finished paintings.

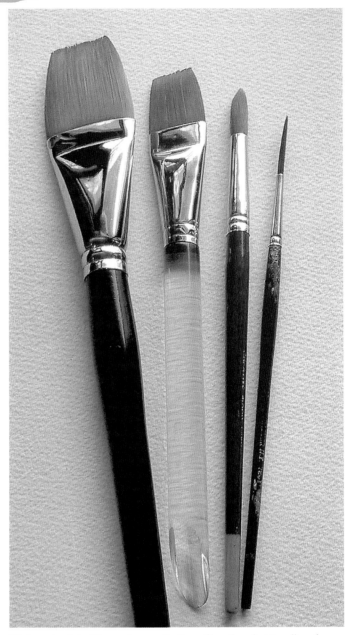

Like most artists, I have a large collection of brushes, but I really only work with about three or four—a 1-inch (25mm) flat, a no. 12 round and a no. 3 or 4 rigger—for sketching. For larger paintings I add a 1¹/₂-inch (38mm) flat brush.

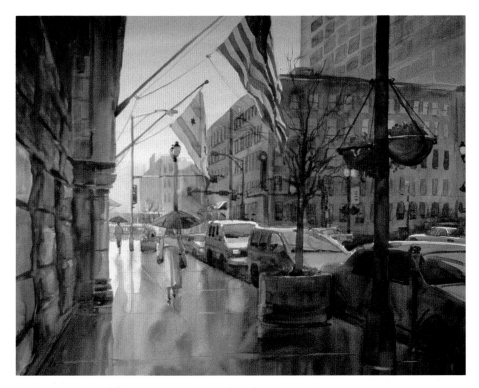

Can you tell the difference between the brushes I used in these two paintings? I did this painting with an expensive kolinsky red sable brush.

COURT HOUSE LOOKING EAST • Watercolor on Strathmore 5-ply bristol board • 22" × 25" (56cm × 64cm)

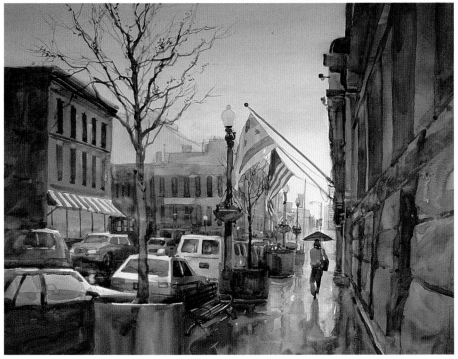

I did this painting with an inexpensive white nylon brush. It doesn't really matter what brush you use as long as it comes to a nice point and holds the pigment and water well. There are many high-quality brushes, both inexpensive and very expensive.

COURT HOUSE LOOKING WEST • Watercolor on Strathmore 5-ply bristol board • 22" × 24" (56cm × 61cm)

Tip Choose whatever brush works well for you. But remember, brushes are only as good as the artists behind them.

Designer Sketch Boxes, *Designed by You*

With all the sketch boxes and storage boxes on the market, it isn't difficult to find or make something that will work for your particular sketching needs.

If you're only sketching in pencil, a simple folder or sketch pad will do. If you plan to add watercolor to your sketches, get a portable sketch box that is easy to set up, has room to store regular-sized brushes and paper and has a good water container. Most sets don't have a great system for using water. Creative thinking comes in handy here. Put together a self-made sketch box following the instructions below to make one that fits your needs. If making your own sketch box doesn't appeal to you, look for a good Pochade box. Check your local art store, art magazines and the Internet.

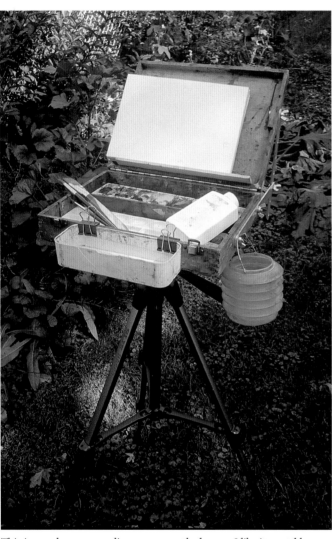

This is my always-expanding, never-exactly-the-way-I-like-it, portable sketch box. I made it from an old oil painting box that I keep adjusting. This latest version attaches to a tripod and holds a decent-sized painting or sketch.

Find a container that isn't too big or too small. It should hold paper the size you normally use, which shouldn't be too much larger than 8½" x 11" (22cm x 28cm).

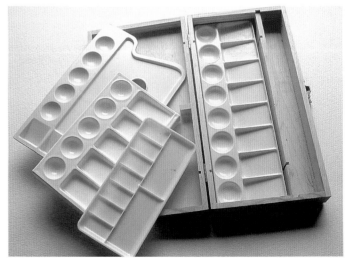

Add a palette. Attach a surface for mixing colors. Any white plastic container will do. If it's removable, it will be a lot easier to clean.

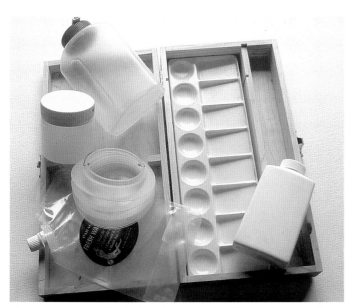

The water container should be leak-proof and stable so it doesn't spill. I've used a glass olive jar, a baby food jar, small plastic storage containers and a skinny plastic bottle, but I'm always looking for something better. Grocery stores have some great containers that you can recycle.

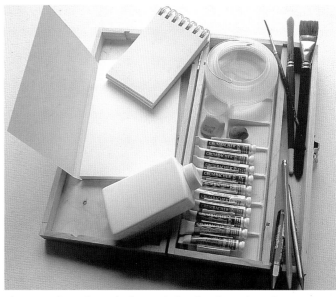

Place everything else in the box, including brushes, tubes of paint, pencils, a small pencil sharpener or knife, an eraser, small clips and paper.

To get fancy, add a tripod and something to hold the lid of the box open. Explore your local hardware store for ideas.

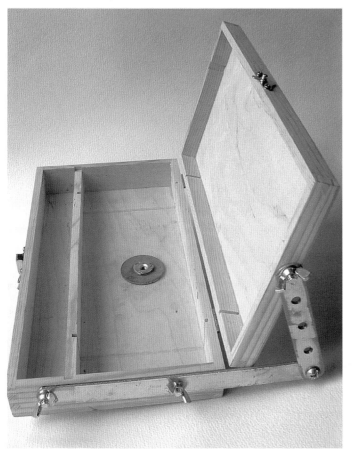

The Digital Dimension

The computer age has brought many useful devices to the artist's table. With the computer and the digital camera, the artist can take and store reference photographs by the hundreds without paying for film or processing. Programs, such as Adobe Photoshop and Corel Painter, allow you to manipulate photos to your liking. Reasonably priced color printers give you the option of painting from a color printout or the monitor. Here are just a few examples of what an artist can do in the digital age, such as changing the lighting, making a photo black-and-white and combining reference photos.

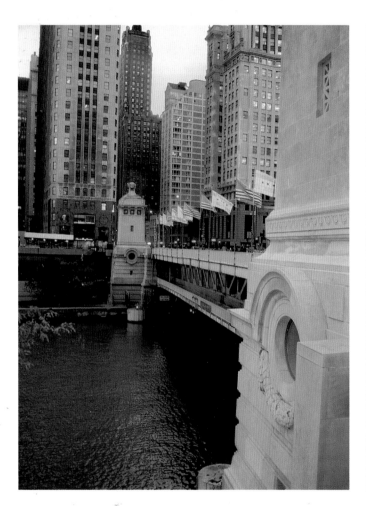

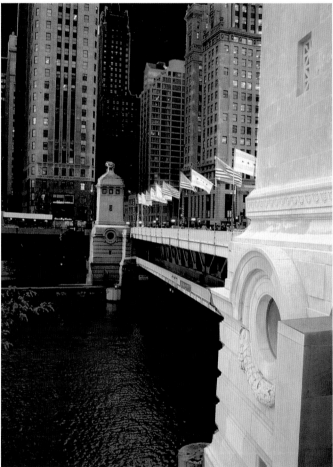

A Simple Silhouette Sketch

Always test a new art product before you do anything else with it. Don't wait until you're working on a painting to see how a new product behaves. Sketching, though, is a great time to test new materials.

Silhouettes are easy to sketch and provide a good stepping stone to more difficult paintings. The dark overall tone and lack of detail prevent students from worrying about ruining a painting with a single brushstroke. As you do these exercises, focus your attention on the following lessons:

- Pay attention to the ways the different materials handle.
- Paint from light to dark and from back to front.
- Paint through objects rather than around them. Objects become darker closer to the foreground, both on your canvas and in real silhouette scenes.
- Concentrate on creating rich, colorful darks.
- Concentrate on drawing and painting large value masses.
- Concentrate on the edges and forms instead of details. Learn to paint smooth, soft washes and hard, detailed edges.

Take these lessons with you as you move on to more difficult scenes. Every once in a while, return to sketching silhouette scenes to get back to the basics.

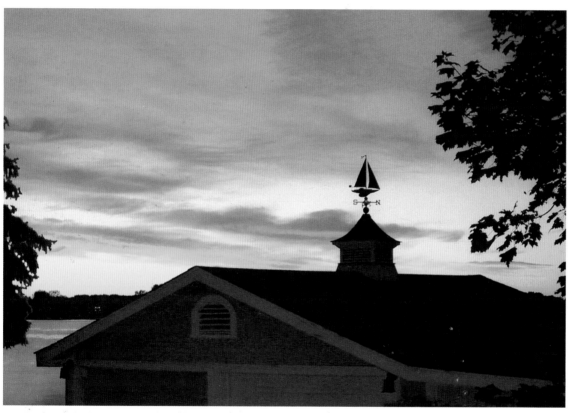

Use this photograph to practice a few sketches with the materials and techniques on page 41.

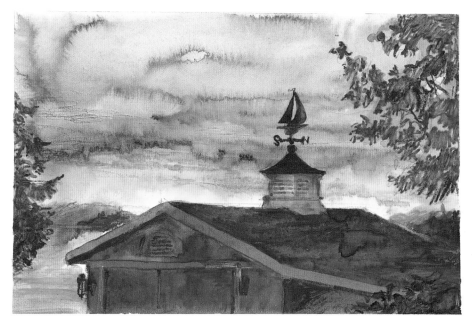

Use a sheet of paper and some watercolor pencils that you normally wouldn't use, whether they differ by color or brand. Sketch the photo on page 40, and then add water to see what happens. Keep a mental log of the way the pencil, paper and water handle, or write down what you like and dislike about the new materials.

I used Derwent watercolor pencils on 140-lb. (300gsm) Arches hot-press colored paper. As I did the exercise, I noticed that I would have liked the pencil to cover more thickly. Perhaps a woodless pencil might have laid down more color. Also, getting a soft edge on this smooth, hot-press surface while adding water was difficult. Next time, I'll know to paint the washes with regular watercolors and save the watercolor pencil for details. Remember or write down the good and bad experiences of each sketch for reference for future sketches.

Again use a sheet of paper that is new to you. Get three colors of paint you've never tried before. It doesn't matter what colors you choose; you're just experimenting. Use the photograph on page 40 or one of your own. Do a sketch using only those three colors and, for another twist, use only an angle shader brush for the entire sketch.

For this exercise, I used tinted yellow 300-lb. (640gsm) watercolor paper, a bottle of Aqua Blue watercolor dye, a half-pan of Burnt Sienna, a tube of Lemon Yellow and a 1-inch (25mm) flat angle shader.

My observations during this sketch involved the way these colors interacted with each other. There didn't seem to be any problems mixing the colors together. The brush was a bit strange at first, but as I went along, I learned to use the pointed end as if it were a round brush. The dye color at times overpowered the other colors when I mixed them on my palette.

Make up your own combinations of materials and improvise. Who knows? You may bring on the next art movement.

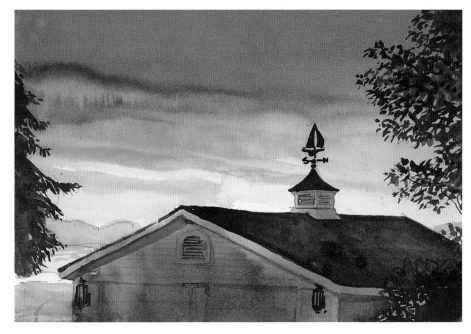

preliminary sketches
IN DRY MEDIA

Many find the preplanning stage difficult and not worth the time. It may feel as if you're duplicating work and that the extra effort isn't really helping. The list of excuses for avoiding preliminary sketches goes on and on. Doing preliminary sketches is a lot of work, and it can be hard. But if you use sketching as a way to learn and practice rather than going through the motions, your skills and your paintings will improve.

MICHIGAN AVE BRIDGE

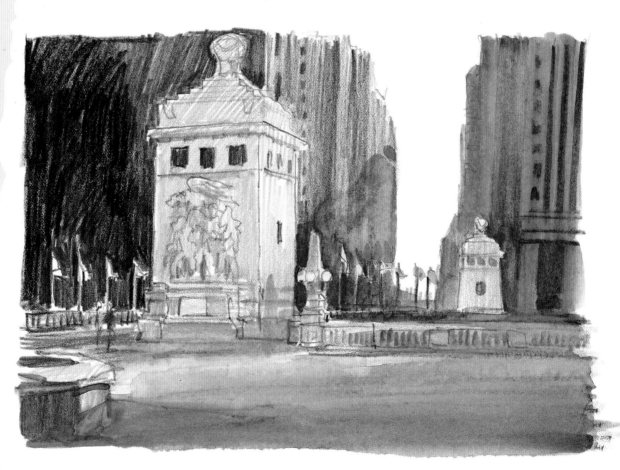

What a View!

You should plan every painting you do by sketching the scene before putting brush to paper. You also should plan your sketches before putting pencil to paper by creating good compositions. It may take a few thumbnail sketches before you find a good one, but if you pay no heed to composition, your paintings will show it no matter how much sketching you do.

Always carry a viewfinder when sketching outdoors or painting plein air. They're pretty easy to manufacture on the spot; it just takes two hands! Any other object that creates a small box or rectangle to view and frame a live subject also can serve as a viewfinder. I use a cardboard slide holder. It's small, lightweight and easy to use. The viewfinder on any camera also works well.

A viewfinder crops a scene to fit the rectangular dimension that makes a well-composed picture. When outdoors, you'll find there is too much to take in, and the task of capturing the scene on paper easily can become overwhelming. A viewfinder brings the scene back to a simple, four-sided picture that is easier to comprehend.

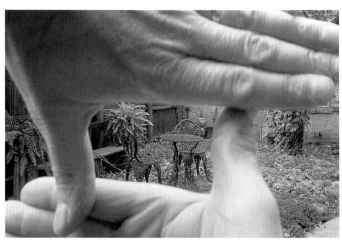

By forming a rectangular shape with your hands and fingers, you always have a handy viewfinder in your pocket. Notice that the hands in this picture are out of focus. Treat your own handmade viewfinder the same way. Don't focus on your hands; instead focus on the subject and its pattern of lights and darks.

Tip Sketching without a good composition in mind is like sketching in the dark: You can do it, but the sketch won't help you much when it comes to the final painting.

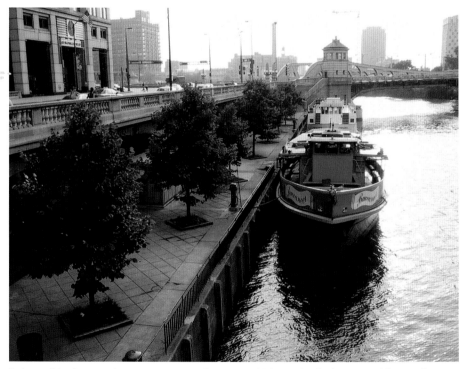

Let's say this photograph represents an outdoor scene. Using a viewfinder, try to pick out a few areas from this photo that make good compositions. Make sure your choices have interesting centers of interest and good value patterns.

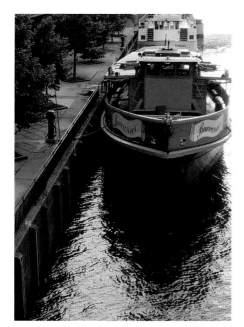

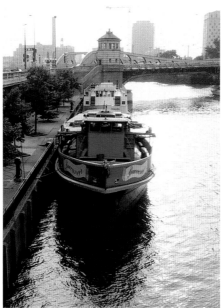

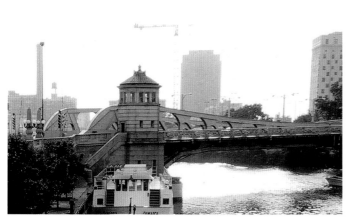

I chose the three scenes above with my viewfinder and ended up with the sketch at right.

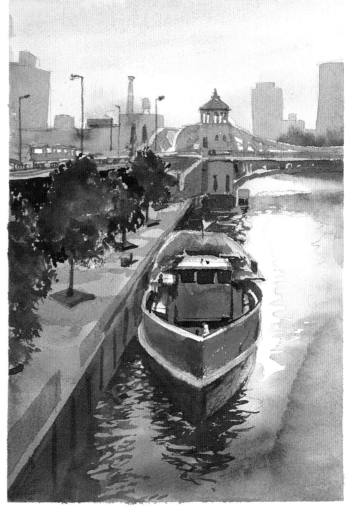

CHICAGO RIVER PARTY BOAT • Watercolor on Arches 300-lb. (640gsm) rough • 14" × 9¹/₂" (36cm × 24cm)

Forget Details, Think Big

If I had room to teach only one principle in the fundamentals of art, it would be to look at the big picture. Looking at the big picture means that an artist needs to work out all of the large shapes, large value patterns and big angles before he or she starts work on the details. It doesn't matter if you're sketching, drawing, painting or using one medium or another. Just work out the big first and finish with the small.

When starting a drawing or sketch, many make the mistake of starting with details—an eye, for example—and trying to build from there, drawing the head around the eye and then the body around the head. That's working backward and letting the details compose the painting. Instead, start drawing the large angles and shapes, and then work your way to the details.

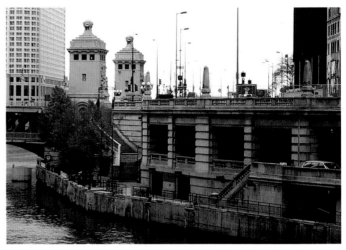

Do a pencil line drawing of this photo, looking for the large angles.

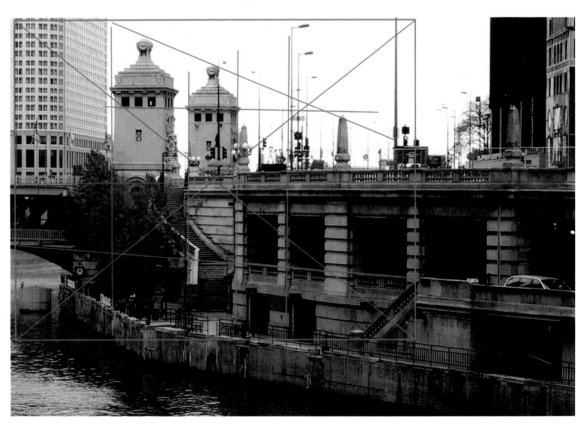

Here are the main angles and shapes that stuck out to me.

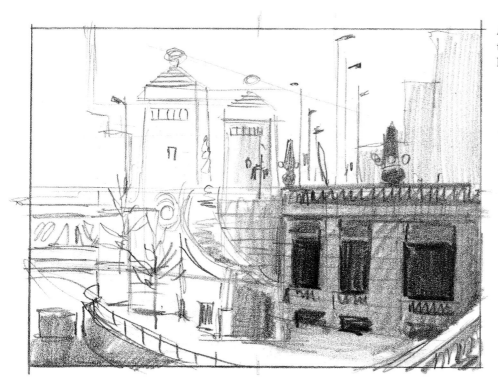

Add large patterns of value with a 6B pencil to create large shapes. Squint your eyes while looking at the photo to see the value pattern.

Tip Squinting your eyes at a reference photo or scene lessens the impressions of detail and color. Simplifying the values this way makes the process of sketching or painting the true values easier.

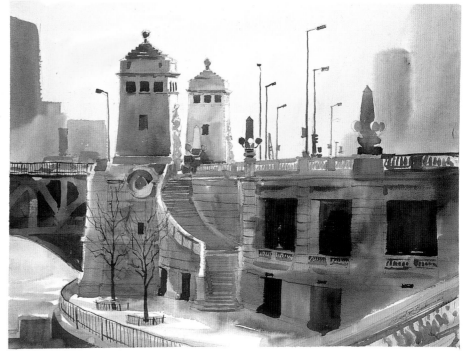

MICHIGAN AVENUE TOWERS • Watercolor on Arches 300-lb. (640gsm) rough • 21" × 29" (53cm × 74cm)

Composition Dos *and* Don'ts

Many beginning and even advanced painters fear the thought of putting down that first brushstroke on a blank sheet of paper or pure white canvas. After that there's no going back. It's an easy fear to overcome. Just make your first brushstroke on sketch paper instead of watercolor paper or canvas. If you don't like the result, throw it out. If you do like it, finish your sketch and move on to your painting with confidence. Do a rough preliminary sketch—a thumbnail, value sketch or color sketch. Working up a sketch prior to painting gives you confidence in what is yet to be created and provides a blueprint to help you get to that creation.

No matter what level you've reached as an artist, the basic fundamentals of sketching play an important part in your creation. Practicing scales does not itself make a musician great, but it does make him or her better. And although following the fundamental principles of art doesn't make an artist a master, this practice does make the artist better and does bring the artist closer to his or her full potential. The following principles are guides to what works and what doesn't when composing a painting. The more experienced an artist becomes, the less he or she has to think about these fundamentals to use them, just as an experienced musician plays a song with feeling rather than concentrating on individual notes.

Use the knowledge you gain here to make sure your sketches have compositions that work. Better sketches are the key to better paintings. These wrong/right examples show how I used each fundamental principle to change a bad composition into a good one.

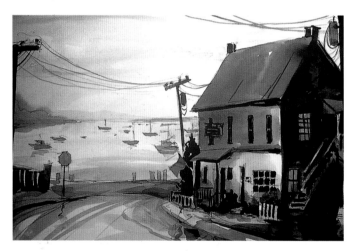

Keep the weight of the object within the painting evenly distributed. Don't cut the painting in half by putting all of the objects on one side and leaving the other side empty. Think of your painting as if it were on a balance. If one side is overloaded, the painting will appear heavier on one side and thus lopsided. Keep elements like telephone poles away from the edges or sides of a painting.

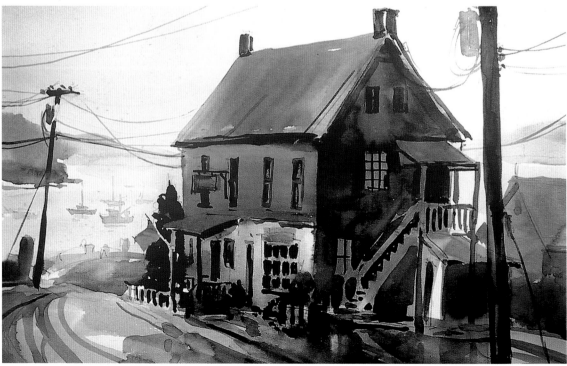

PORT CLYDE ICE CREAM SHOP · Watercolor on Strathmore 5-ply bristol board · 8¼" × 13¾" (21cm × 35cm)

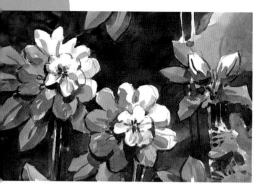

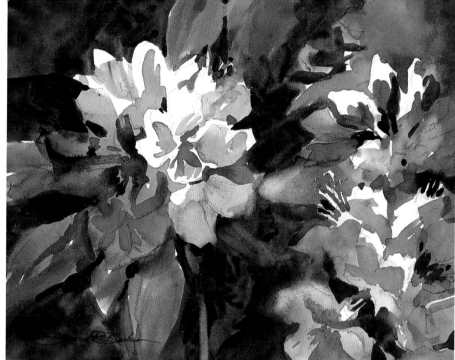

If you're painting a number of objects that are about the same size, use them in odd numbers, and, if possible, adjust the sizes so they differ. I eliminated one of the two flowers in this painting to create an odd number. The line work that outlines the flowers is another problem. Use different value masses rather than line work to indicate dimension and shape.

MOM'S FLOWERS • Watercolor on Strathmore 3-ply bristol board • 8" × 13" (20cm × 33cm)

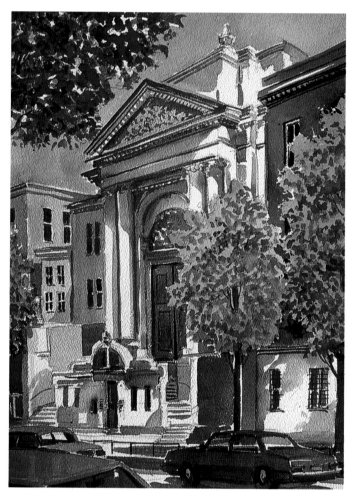

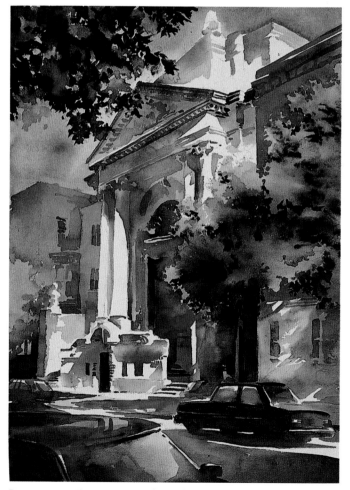

Avoid overcrowding a scene. Simplify the value pattern to include only large value masses. You can make the smaller shapes as detailed as you want as long as everything in that mass remains close in value. Don't paint each object separately or in pieces. The simpler the composition, the better.

DOCTORS ON ERIE • Watercolor on Aches 300-lb. (640gsm) rough • 20" × 14¹/₂" (51cm × 37cm)

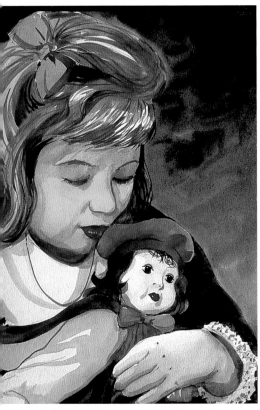

Watch out for tangents. Two objects that meet each other exactly on outside edges create an optical illusion that flattens an image and draws attention to that particular spot. Objects should overlap to create dimension. Letting objects run off the page also indicates dimension. Even though this painting isn't a landscape with a lot of depth, I still needed to show distance and watch out for tangents.

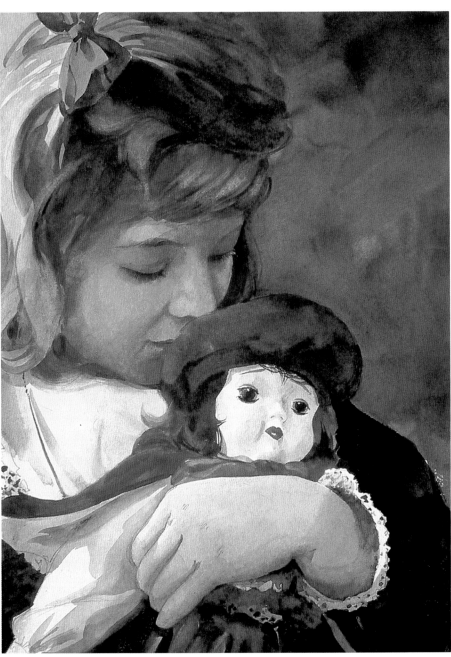

Tara and Doll · Watercolor on Crescent cold-press watercolor board · 19" × 15" (48cm × 38cm)

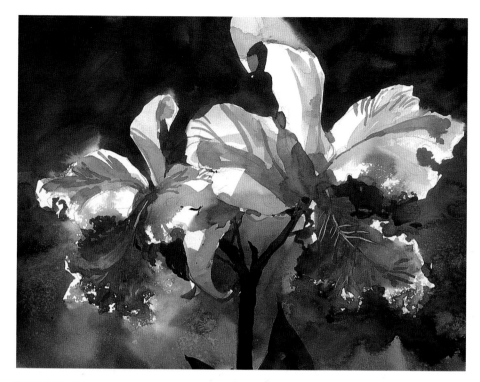

Learn to create both formal and informal composition. A formal composition is one in which symmetrical objects or areas are placed in the center to create a kind of bull's-eye effect.

Formal composition is not a bad form of composition, but artists should experiment with both formal and informal composition. Both of the paintings on this page are compositionally correct though each uses a different form of composition.

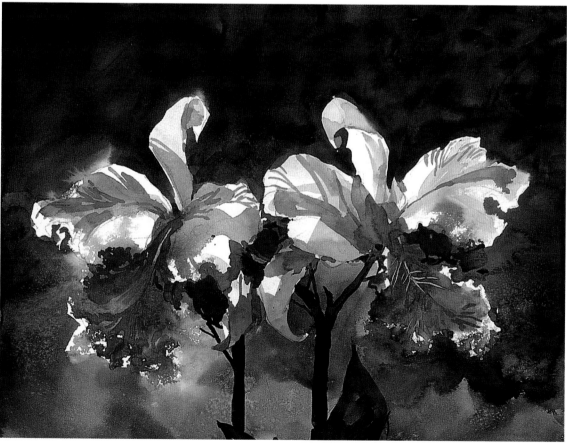

These dos and don'ts and fundamentals are not mathematical formulas or surefire ways to create great paintings. They're simply basic elements for creating pattern, dimension, balance and flow in your work.

FLOWERS FOR YOU, SHARON • Watercolor on Arches 300-lb. (640gsm) rough • 11" × 14" (28cm × 36cm)

Thumbnail Sketching

Now that you know how to compose a scene, you can move on to the sketching stage. Of all the kinds of preliminary sketches, thumbnails are the fastest and easiest. If you do no other sketch before starting a painting, do some thumbnail sketches.

A thumbnail sketch is a very small sketch. Use it to determine the general layout and value pattern of a painting. Whether painting on the spot or working from a model, still life or photo, you must determine how the image will fit into the space you are working on, and you must decide which elements to focus on. This means breaking the values down into simple patterns. The thumbnail doesn't need detail. That can come during the actual painting.

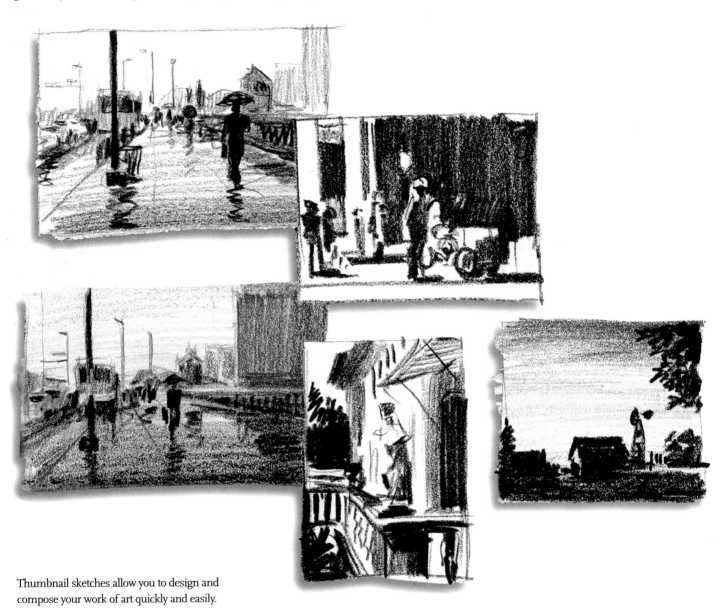

Thumbnail sketches allow you to design and compose your work of art quickly and easily.

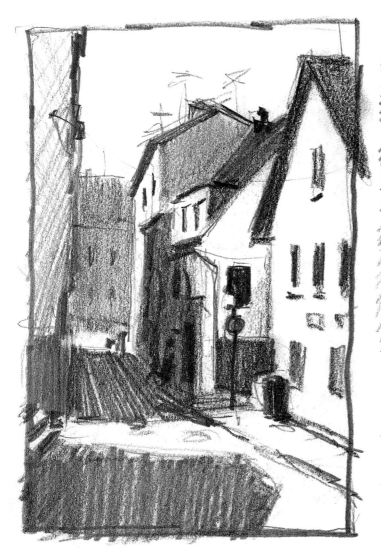
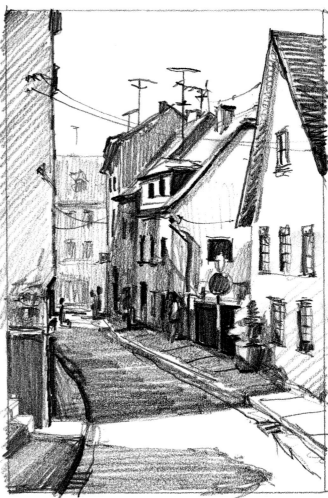

These sketches demonstrate how simple you can make a thumbnail sketch (at left) compared
to a more finished value sketch (at right). A thumbnail sketch simply needs a defined, framed
dimension—a horizontal or vertical layout—and a large value pattern. Don't worry yet about color,
details and well-defined edges.

Black-and-White Value Sketching

The value sketch is a more complete, tighter and larger version of the thumbnail sketch. Plan your values more carefully here. Value sketches are extremely important when designing a finished work of art, especially if you need to change the scene or combine two scenes for a better composition.

Combine these reference photos into one improved scene with a pencil value sketch.

Tip Value sketches usually are done in one color so you can concentrate on values instead of colors. You can do them in any medium as long as that medium allows a good range of lights and darks.

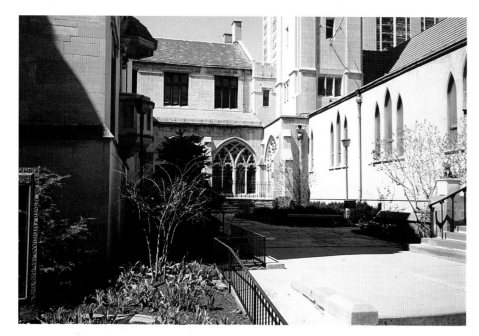

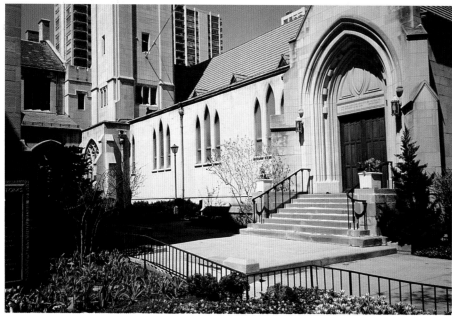

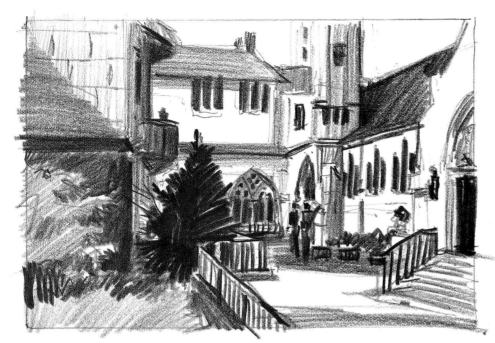

I did this value sketch with a 6B woodless pencil on an ordinary sketch pad. The sketch measures about 5" × 7" (13cm × 18cm). Don't do value sketches too large. Working too large will tempt you to add more detail than necessary in the sketching stage. Value sketches are not supposed to be finished works of art. Instead, they should be rough blueprints to help you complete a larger finished painting.

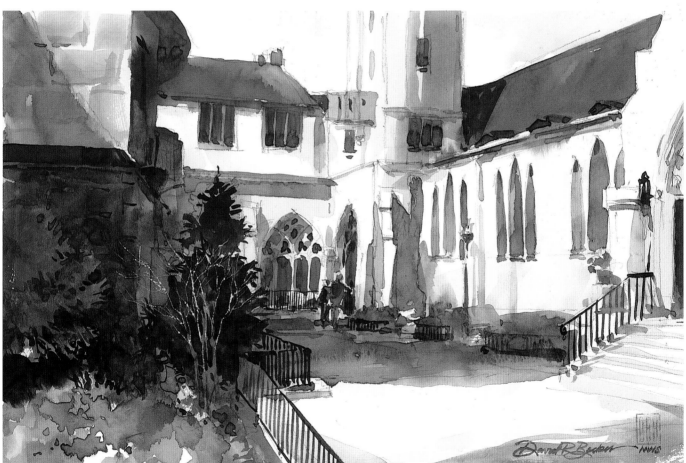

Notice that the values in this painting follow the pattern in the value sketch at top. The finished painting is a well-organized piece of art, but the value sketch is what makes it so.

ST. CHRYSTSOMS ON DEARBORN •
Watercolor on Crescent cold-press watercolor
board • 9¹/₄" × 14" (23cm × 36cm)

Color Value Sketching

Think of a color value sketch as a value sketch with an added bonus. A color value sketch also allows you to work out a color scheme and add more dimension using cool and warm colors together. You can do both a pencil value sketch and a color value sketch, but if you're only going to do one, do a color value sketch. No matter what, don't forget the main reason for any kind of value sketch: working out a good value pattern. Get a sketchbook of regular drawing paper or thin watercolor paper. Use it to do small color value sketches. Date the pages and write down comments as you would in a journal.

For this exercise, draw a line drawing and add value with color instead of pencil, taking the intensity of your colors into account. Work out two sketches, each with a different color scheme.

Tip When looking at a color scene, squint your eyes to see the values and open them to see the intensities and hues.

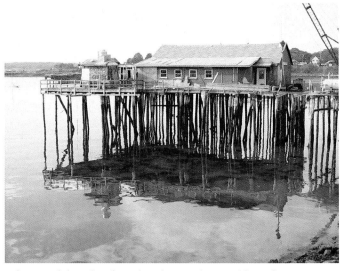

I eliminated the colors from this photo so they wouldn't influence your color choice. At this stage I'm more concerned that you see the large values in the photo than trying to match colors to those values. Use whatever colors you prefer at this point. An easy rule is to use intense, warm colors in the foreground and gray, cool colors in the background.

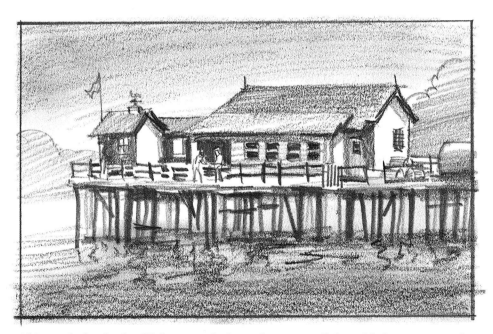

This pencil value sketch will help you see the large value pattern of light and dark. Use it as a guide for the values you need to put into your color value sketches.

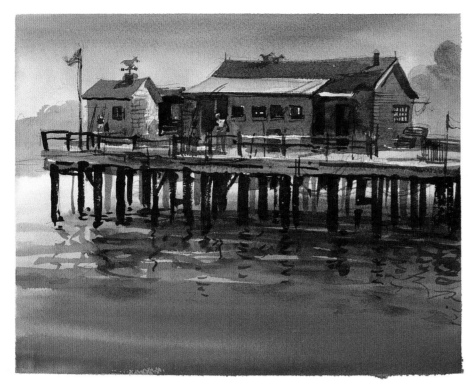

Here are the two
color value sketches
I did for this exercise.

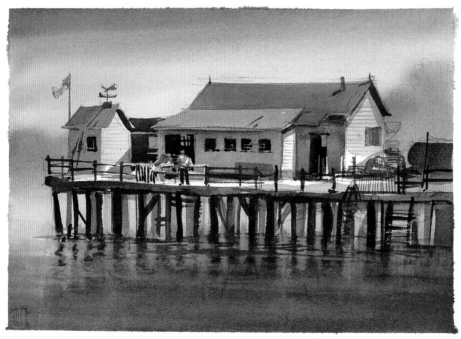

Add Life *to* Your Paintings

One of the biggest mistakes artists make when putting figures or animate forms into paintings is adding them as afterthoughts. Artists see areas that seem empty and try to fill them. Don't use people as a solution to that problem. Instead, use sketching and planning to avoid those empty spots and include figures right from the beginning. Incorporate the shapes, values and colors of the figures now so they'll work with the composition of the entire painting. There are three ways to incorporate animated forms into paintings.

When painting a portrait, compose the painting around the figure.

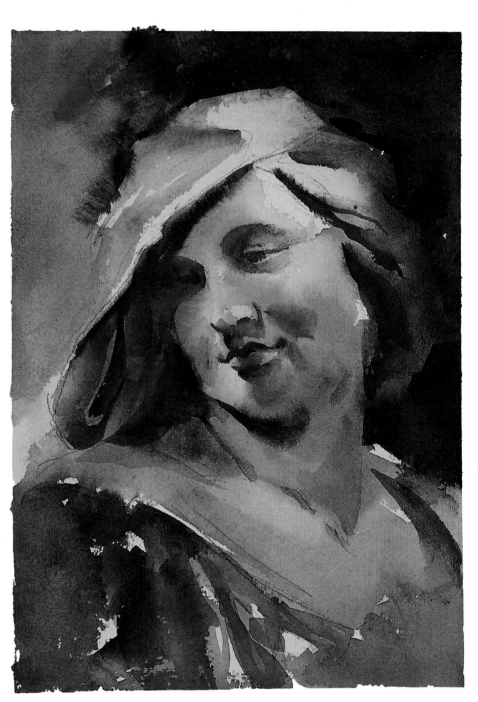

SCULPTED LADY • Watercolor on Arches 300-lb. (640gsm) rough • 12" × 8½" (30cm × 22cm)

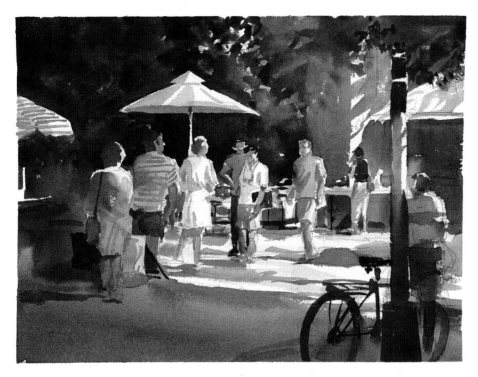

Landscapes can show the animate form as the center of interest, but don't rely solely on the figure to create good composition.

DEARBORN GARDEN WALK 2000 • Watercolor on Arches 300-lb. (640gsm) rough • 10" × 14" (25cm × 36cm)

When placing figures in a landscape as accents, paint them so they don't attract attention. It's a difficult task; figures, along with lettering, are the first elements the subconscious mind sees in a painting. To place figures successfully, place them so they don't compete with the center of interest.

DEARBORN PORCH • Watercolor on Arches 300-lb. (640gsm) rough • 10" × 14" (25cm × 36cm)

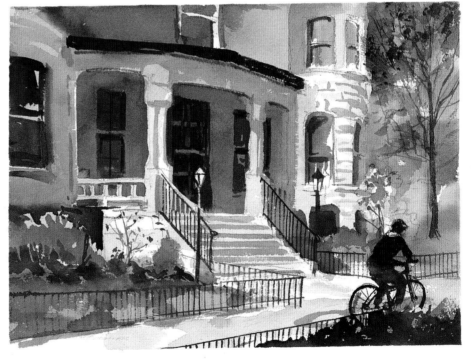

Sideline Sketching

For many, drawing and simplifying details and shadows in a figure or large group of figures is difficult. Use sideline sketches to work through this problem.

You've probably never heard the term "sideline sketch" before, and you won't find it in any dictionary. I use the term to describe a sketch done on the side of a painting or in a sketchbook to solve problem parts of a painting. You can do sideline sketches before you start the painting or when you get stumped during one. These sketches are extremely helpful for putting figures or other complex elements that need to be simplified into a painting.

I did this sideline sketch to better understand how the values and shadows work together to form patterns that I can use in the figure study at right.

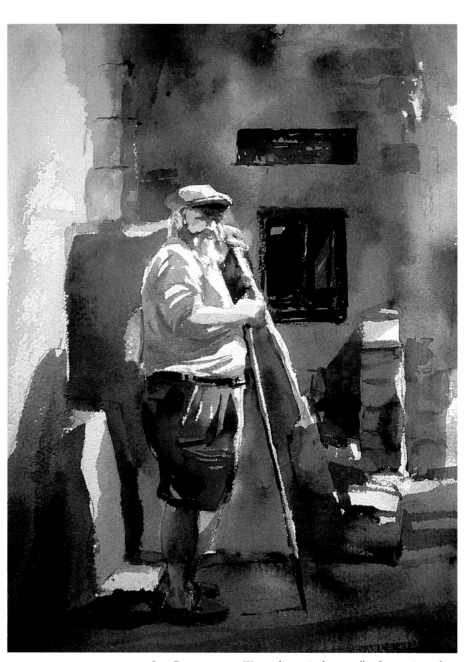

Jim Relaxing • Watercolor on Arches 300-lb. (640gsm) rough • 10" × 14" (25cm × 36cm) • Collection of Jim Lane

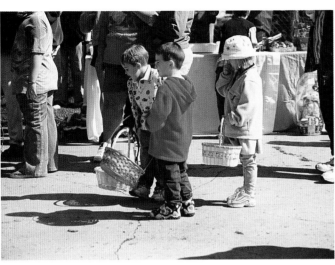

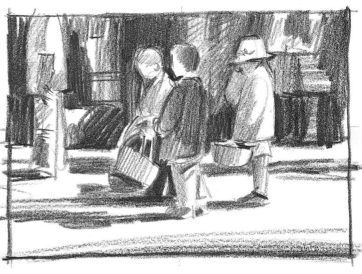

I want to use the figures in this photo as the center of interest in a painting, but the lighting and other aspects of the photo won't match my composition. Now is the perfect time for a value sketch and a sideline sketch.

This value sketch shows how the figures will fit in the composition.

The sideline sketch shows how the details of the figures will look.

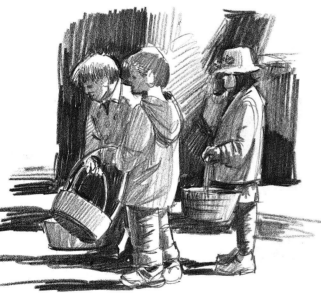

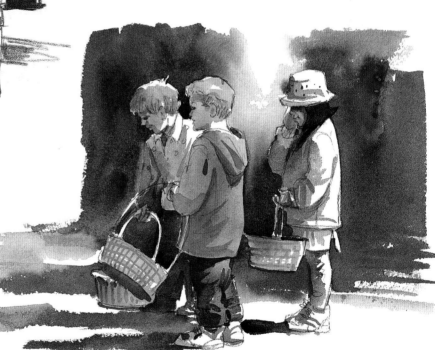

You also can do sideline sketches in watercolor, especially when trying to decide what procedures and colors to use on the actual painting.

A High-Tech Helper

There always will be new materials and tools for artists to use and experiment with. It's up to the artist to decide whether to pursue them or not. Many artists have trouble breaking with tradition and their education to experiment with the new. Tradition does have value, but the digital camera and the computer are worth taking a chance on. The computer doesn't paint or think for you. Like a paintbrush, it's only a tool. So let's look at how we can use it to create better fine art.

If you have a computer, you need a digital camera. It's the best invention for an artist who works from photographs since the inven-tion of photography itself. They take great pictures and are as easy to use as standard cameras. They free you of the costs of film and developing, and you can look at a photo instantly to see if the picture turned out to your liking. If the photo isn't good, simply delete it and try again. You can change the composition, values or even colors on a computer. You can see how the scene and composition might look before you paint it. You also can download images from a digital or video camera for reference and save thousands of reference photos on CD or disk.

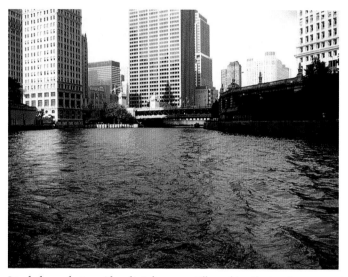
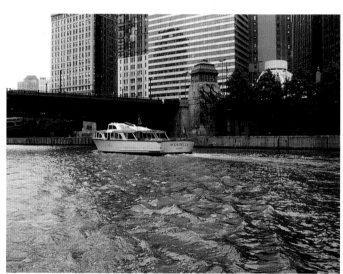

I took these photos with a digital camera. I'll combine the two images on the computer to make one well-composed reference. Then I can paint from the screen or a printout.

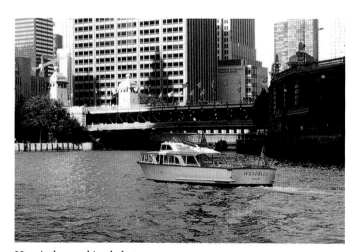

Here is the combined photo.

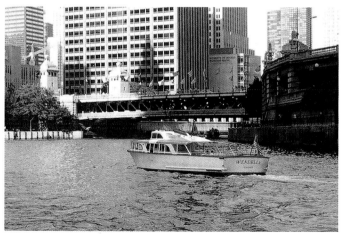

I made the image black-and-white to better see the values.

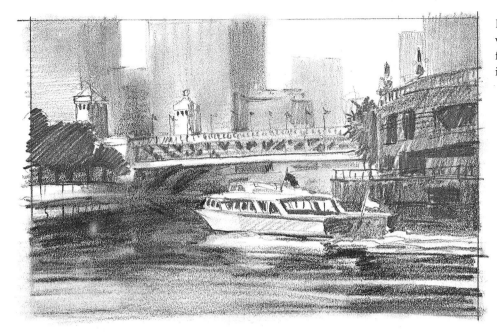

I do a value sketch even when I have played with a photo on the computer. Getting the feel of the values is a big help when painting in watercolor.

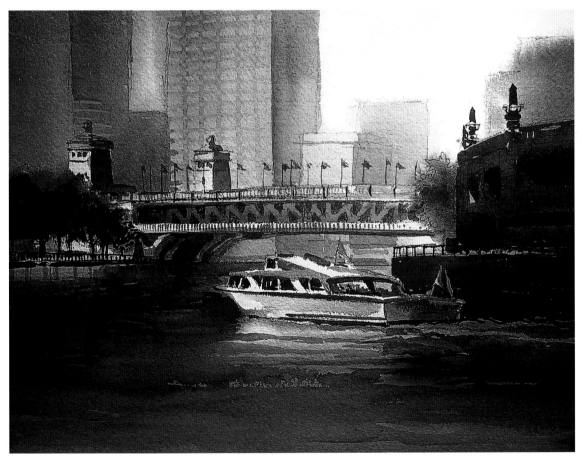

WENDELLA BUS • Watercolor on Arches 300-lb. (640gsm) rough • 10¹/₂" × 14¹/₂" (27cm × 37cm)

3 watercolor SKETCHES

Many consider watercolor one of the hardest mediums to paint in. You can apply many coats and scrape or erase pigment in other mediums. But a few coats of watercolor is all you get, and preplanning is a must. Still, the process of painting with watercolors actually isn't harder; it's just different. It's all in the planning. If you don't plan a painting before applying paint, it won't matter what medium you're using. And once you've planned a watercolor painting, the painting process is as simple as in any other medium. Planning makes the painting part—no matter what medium you're using—easy.

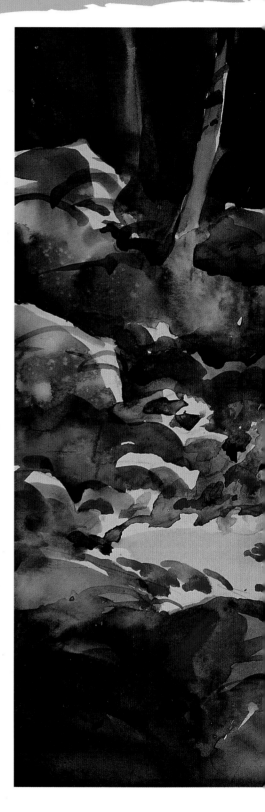

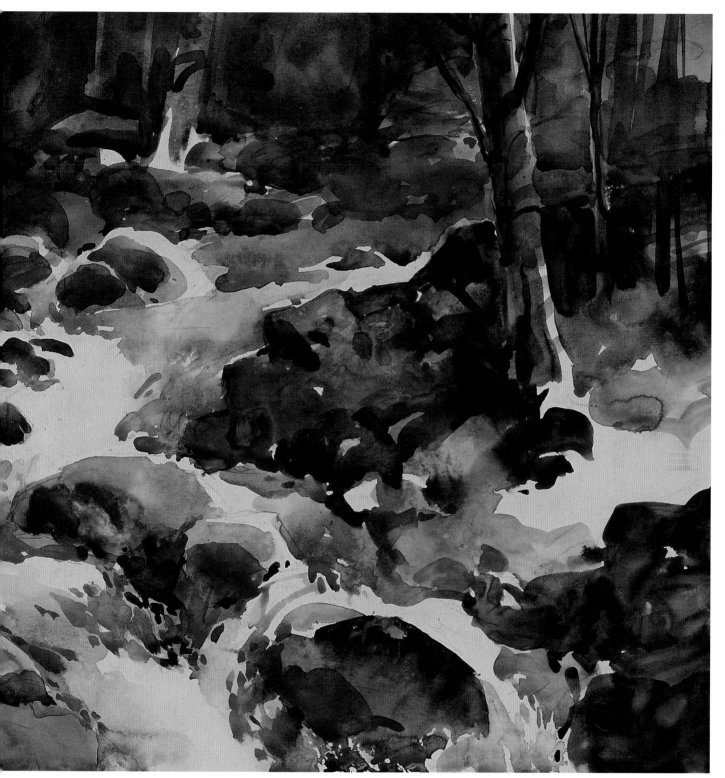

CANADIAN RUNOFF • Watercolor on Arches 300-lb. (640gsm) cold-press • 16" × 20" (41cm × 51cm)

Going *Through* Stages

A planned painting goes through three major stages. A value sketch is a small, rough drawing or painting used to figure out a plan of attack for a finished work of art. It also serves as a source of practice and learning for a particular painting and for painting in general. A watercolor sketch is a preliminary value sketch and a finished work of art rolled into one. Plein air painters often use this kind of sketch instead of a value sketch. It should be larger than a value sketch but not as detailed as a studio painting. A watercolor sketch serves as the dress rehearsal for a final painting. Use value and watercolor sketches to help you paint a final painting.

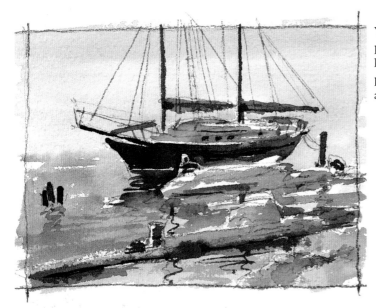

You can use a color value sketch as one of the stages of development of a painting or just as practice. More artists should practice, experiment and learn about a medium with color value sketches. Combining the learning process with painting a finished artwork is like perfecting a blueprint after you've started to build.

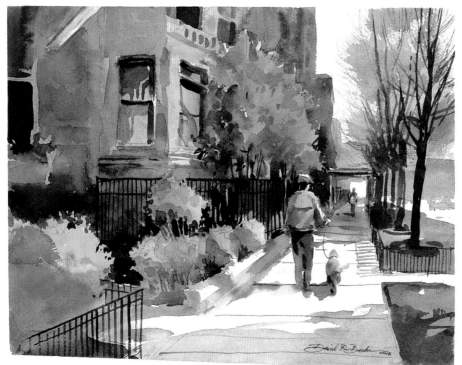

A watercolor sketch is very similar to a color value sketch. Before a watercolor sketch, though, do a thumbnail. Watercolor sketches usually are larger than color value sketches. They also are done in a single sitting, often plein air. Consider the watercolor sketch the second stage of development of a painting.

WALKING DOG DOWN DEARBORN • Watercolor on Arches 300-lb. (640gsm) cold-press • 10¼" × 14" (27cm × 36cm)

Tip To finish a painting, you might go through one of the following scenarios: thumbnail to watercolor sketch to final painting or color value sketch to final painting. Obviously, the more sketches you do, the better your painting will turn out. And, of course, you should sketch as often as you can, not just before each painting, to sharpen your general art skills.

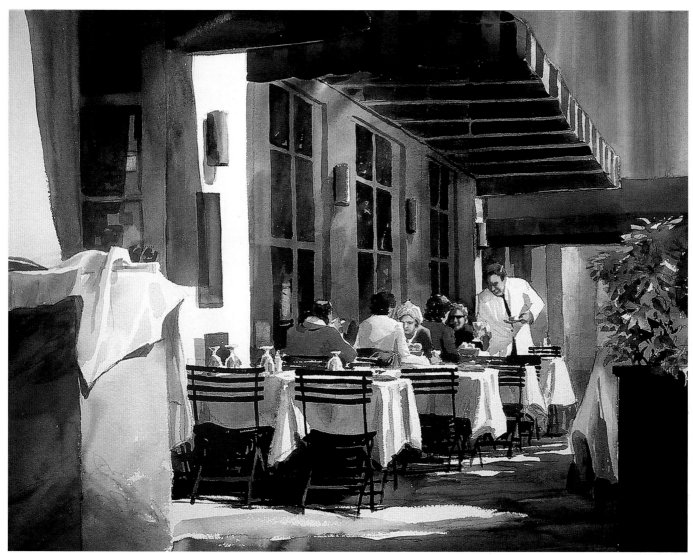

A more finished work of art, or studio painting, is usually larger and more detailed than a sketch. I used a watercolor sketch to prepare for this painting, but you can use a watercolor sketch to plan a painting in any medium. Many masters of the past used the watercolor sketch to plan out their final oil paintings.

EXITING O'NEALS • Watercolor on Arches 300-lb. (640gsm) rough • 21" × 29" (53cm × 74cm)

A Course in Color

You need an understanding of only the basic principles of color for sketching. The basic color wheel and the concept of complementary colors are enough to complete a solid sketch. More important than actual colors are value—the lightness or darkness—and intensity—cool and gray or warm and bright.

Copy the swatches on these pages to get a feel of what it takes to change colors to get certain effects. Don't worry about copying them exactly as they are here. The application, the process you take to change the values and colors, is the important lesson here.

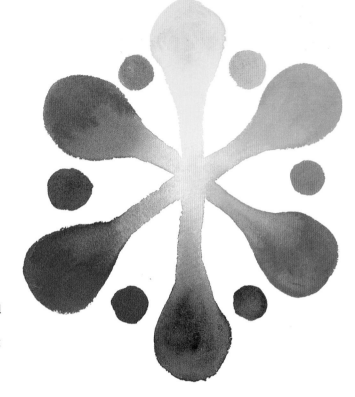

Do a small, quick sketch of this color wheel and keep it in your sketch pad for reference. Then, when painting, set up your palette by arranging your colors in a color wheel arrangement to help you understand and remember the colors.

To gradate a color, begin with an intense version of the color and mix in small amounts of its complement. If you mix equal amounts of two complementary pigments, though, the mixture will just turn brown.

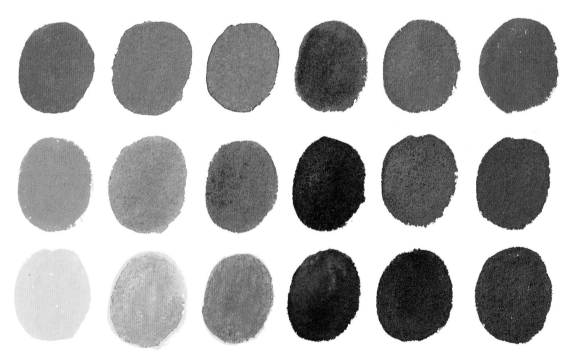

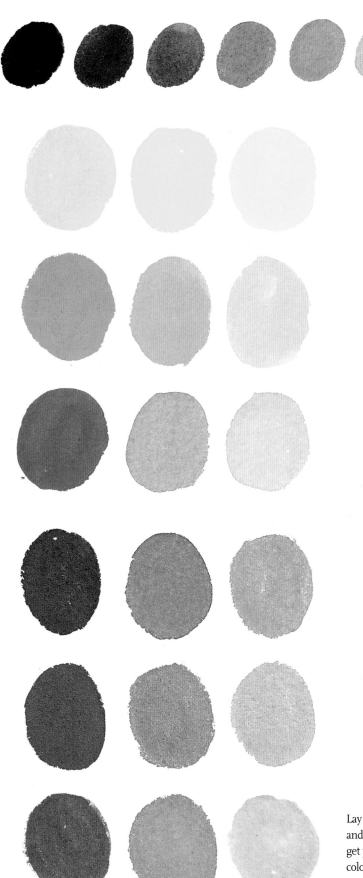

Lay down swatches of pure pigment of black and each primary color. Dilute each pigment to get progressively lighter colors. To lighten any color, add more water.

Limit Your Palette

Learn to crawl before you walk, and start with a limited palette before moving on to a rainbow of colors. There are so many other principles involved in a sketch that color should be the last thing on your list to master. The fewer choices of colors you have, the more creative you'll have to be and the more you'll learn.

Start with one color that you're familiar with. Pick a dark value. You can paint an entire scene with the variety of values you can get by adding water to one dark color. Take a look at the value scale you made during the last exercise. Starting with black allows you to work with all of the values between black and white. Starting with a lighter color, such as a midtone gray, limits the range of values you can use.

Do another sketch with three colors on your palette. Choose dark values of the three primary colors—blue, red and yellow. You can vary the colors a bit, picking a brown from the yellow family, such as Raw Umber, for instance. From these three colors, you can mix secondary colors in addition to changing the values.

Continue to do more sketches, adding one or two colors at a time, until you have a palette that you like and that covers the color spectrum. By then, you'll have a good understanding of how colors behave when mixed together, so you can mix the colors on your palette to create an even wider variety.

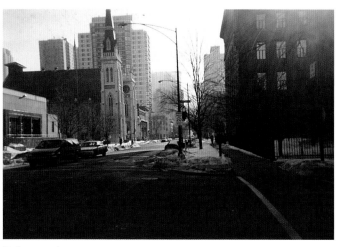

Reference photo

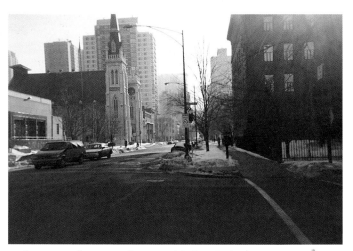

Look at your reference as if it were a black-and-white scene.

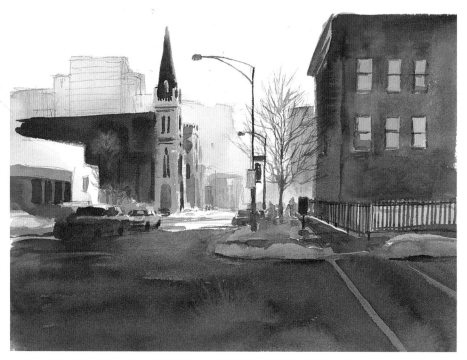

Do a watercolor sketch using one color, preferably a dark value. Dilute the pigment with water to get different values.

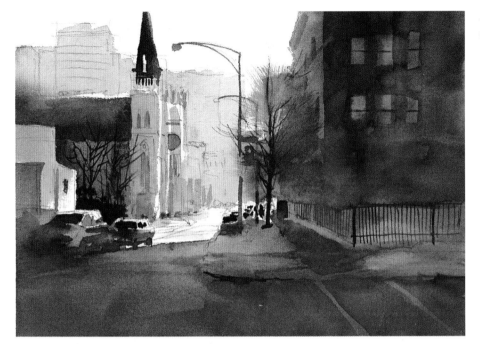

After you get a good handle on one color, do a sketch with three. I used Phthalo Blue, Burnt Sienna and Quinacridone Gold in this sketch.

Tip Choose dark values when painting with a limited palette. If you choose a color or colors that are too light, you've decreased the number of values you can create by adding water. You can create a larger range of values from a dark color.

After mastering three colors, use a full-color palette. Apply what you learned using a limited palette to your full-color sketches.

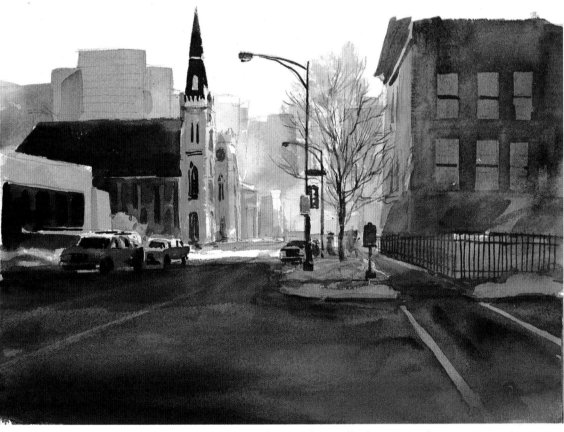

LOOKING SOUTH ON DEARBORN • Watercolor on Arches 300-lb. (640gsm) rough • 10" × 14½" (25cm × 37cm)

Mapping Out Your Colors

Now that you have a handle on basic color theory, let's explore color scheme, an arrangement of colors that work well together. Complementary colors are one example of a sound color scheme. Purple and light green are not exact complements on the color wheel, but they work well together.

When sketching from photographs or sketching plein air, you'll find a variety of colors in a scene. If they complement each other and work in the composition, use them. If they don't, use your artistic license to make the best possible composition. A tree with green leaves, for instance, doesn't always need to be painted green. You can push the colors to fit the painting. If the painting would look better in the painting if most of the leaves were yellowish, shift the green to a more yellow tone. Don't be a slave to an object's local color, the actual color of an object. If an apple is red, you don't have to use only red to sketch it. You can push the red toward other colors and still paint a red apple.

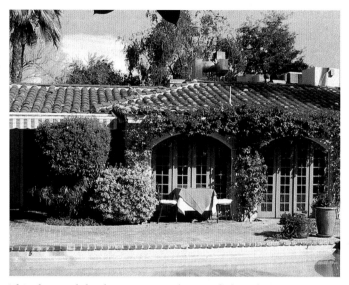

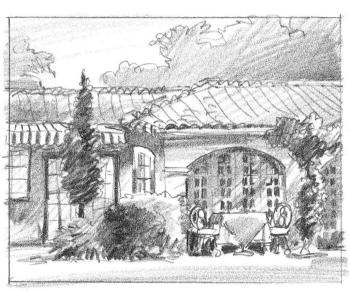

This photo and sketch give me a good sense of what values to use in my watercolor sketch. When painting from a photograph, you should enhance the colors, not just copy them. I'll apply a simple color scheme of blue and orange to the values of the scene.

The color scheme in this sketch, blue and orange, is different from the colors in the actual photograph. That doesn't mean you can't use other colors in the painting. The idea is for the painting to have visual harmony, so I sketched the majority of this painting toward the blue and orange color field.

EUROPA • Watercolor on Arches 300-lb. (640gsm) rough • 10" × 12" (25cm × 30cm)

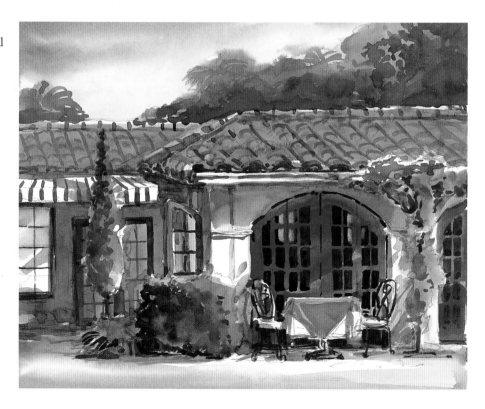

In the color scheme of things, I have always said, "Anything can be any color." Light sources and reflected light can change a color, or an artist simply can decide that an object's color doesn't fit the picture. Artistic license gives artists the right to change colors to make their sketches and paintings work, even if the color isn't true to life. Without artistic license, all artists would be photographers, capturing scenes exactly as they see them. As artists, though, we aim to make these scenes even better than reality.

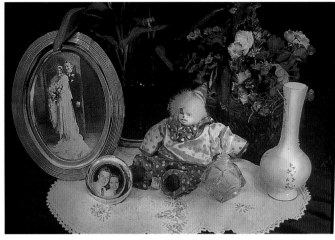

Set up a still life using a white light bulb as your light source and a colored light bulb to reflect into the shadows. Notice that no matter what color an object is, it has a bit of the color of the bulb in it.

Tip The fashion industry always displays the latest color schemes. Designers also work hard to figure out what the next big color craze will be. Artists can pick up these combinations for their sketches and paintings.

This is a quick sketch emphasizing the lighting I used on the still life above.

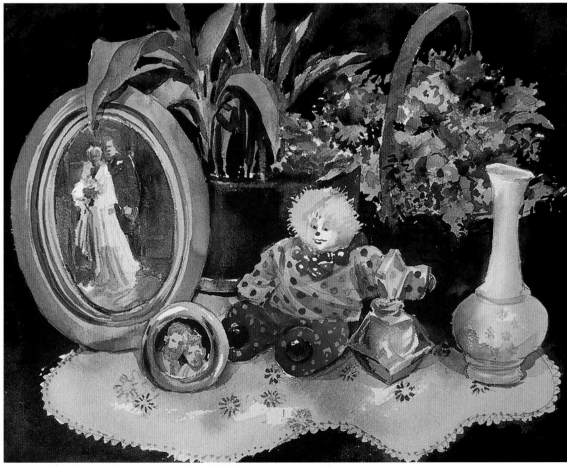

CLOWN STILL LIFE • Watercolor on Arches 300-lb. (640gsm) rough • 13" × 17" (33cm × 43cm)

Trick *or* Technique!?

Technique comes after mastery of the fundamentals. Plenty of techniques produce nifty effects in watercolor; however—and this is a big however—they can't substitute for practice and well-composed and thought-out sketches. Techniques should be used as tools to produce certain elements that are planned in a sketch. The following techniques capture different looks and effects in watercolor. Experiment with each of these in the sketching stages, before applying them to your final paintings.

Scraping

Scrape with the end of a brush with a chiseled handle, a credit card, your fingernail or anything with a hard edge to remove paint from the surface. This allows you to make a white line without using a masking material. When scraping, use enough pigment and not too much water in the original wash. Extra water will run back into the indented surface and create a darker line rather than a white line.

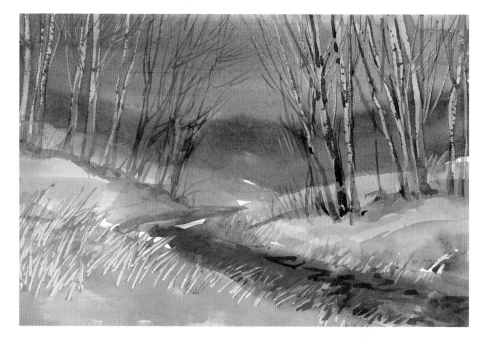

Masking

Masking materials, sometimes called liquid frisket or liquid resist, are great for working on finished works of art to save the white of your paper. Masking sketches isn't really necessary. On a small sketch not meant to take much time, I just use opaque white pigment to show where I would mask on the finished work of art. Apply the masking according to the manufacturer's directions. Follow your line drawing very closely. Applying masking roughly or in a sloppy manner leaves hard edges that look unnatural once you remove it.

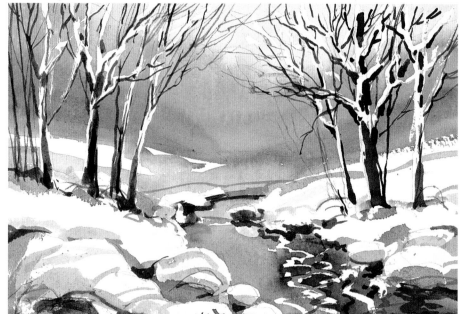

Spattering

Spattering with a paintbrush or toothbrush is a great way to achieve a textured look. Wear clothes you don't mind getting paint on because you'll probably spatter yourself along with your painting surface.

Adding Salt

Adding salt to a watercolor wash results in an interesting texture that looks like little bursts of white or snowflakes. Practice on scrap sheets of paper to get the water-to-pigment ratio right. Kosher salt works better than plain table salt because of the larger size of the grains.

Sponging

Apply texture by dabbing the surface with a rough sponge dipped in paint. Also try removing paint from the paper with a rough sponge or a paper towel.

Misting

Use a spray bottle over dabs of paint or a wash to get a leafy texture. Also use it to wet your surface or to rewet your paints on the palette.

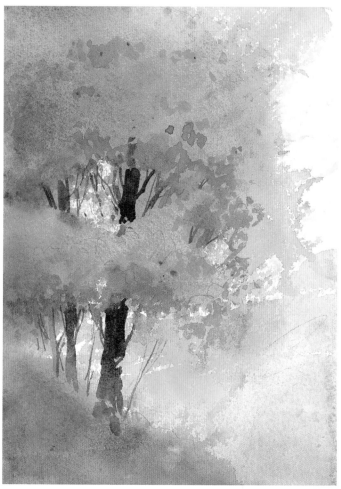

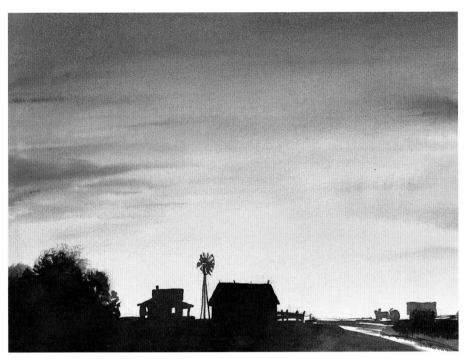

Painting Wet-In-Wet and Wet-In-Dry

Wet-in-wet is a favorite technique of mine. Use wet-in-wet for soft edges and wet-in-dry for hard edges. For wet-in-wet, first put down a clean wash of water on your paper. Then add pigment to the water. For wet-in-dry, put down a mixture of water and pigment on a dry sheet of paper.

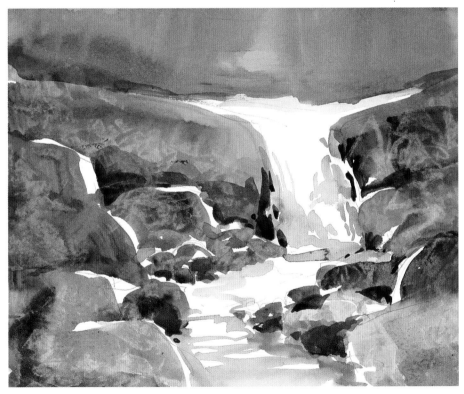

Lifting

Lift pigment off your surface with tissue paper or another absorbent material. You can lift the original layer of paint to return to the white of your paper or lift whatever pigment is still wet to return to the color underneath. In this example, I used crumpled tissue paper to create a textured rock look. The effect is much more pronounced if done on slick, hot-press paper. Rough and cold-press paper absorb more paint, leaving less to be lifted or scrubbed out.

the sketching process
START TO FINISH

In this chapter, I'll take you through three step-by-step sketching demonstrations—sketching in your

sketchbook, outdoors and in your studio—to show you how to sketch, how to apply sketches to a studio painting

and how to apply final details, which you haven't done in the sketching stage. When following along, don't skip any

steps just to get started on the actual painting more quickly. Many feel they would rather spend more time on the

finished work of art than on sketches, but you won't learn good design and composition skills this way. Instead,

think of your sketches as part of the finished painting. Every step from drawing in your sketchbook to adding final

details to a studio painting is part of the process of a worthwhile painting.

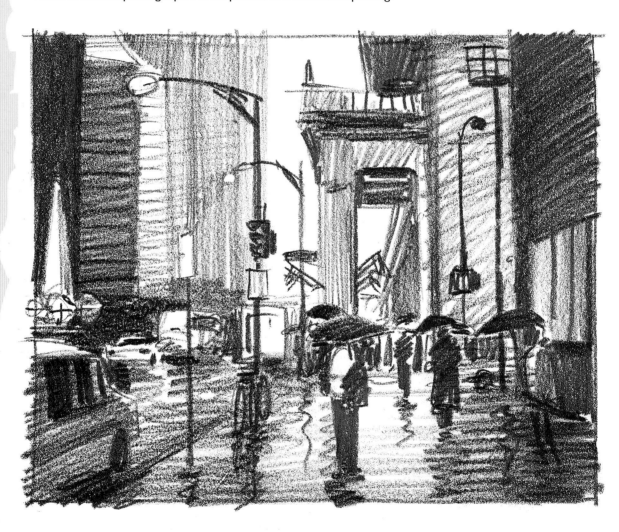

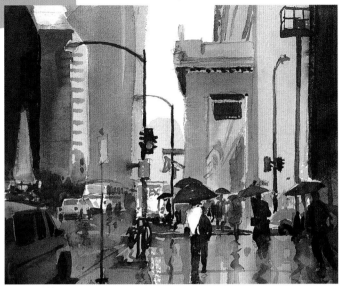

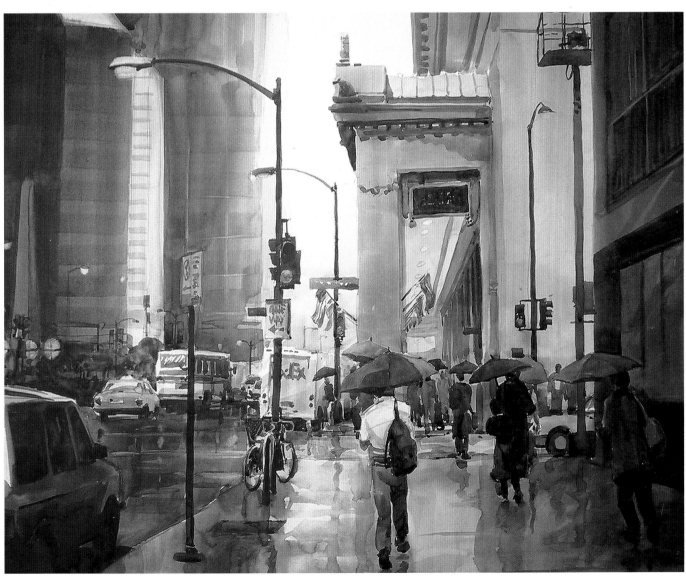

OPERA HOUSE RUSH HOUR • Watercolor on Strathmore 5-ply bristol board • 22" × 30" (56cm × 76cm)

Sketchbook Sketching

1 | **Look for Value Pattern**
This photo is a great reference, but we need to change a few things to make the composition better and more picturesque. Squint your eyes while looking at the photo to see the value pattern. Think dimension.

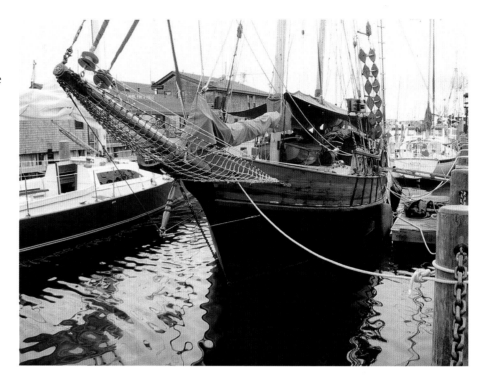

2 | **Draw Thumbnail**
Draw a small thumbnail sketch that includes the changes you want to make to the scene so you have a comprehensive sketch of the scene you want to paint.

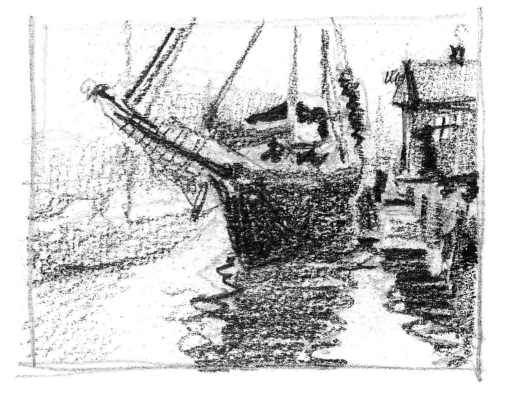

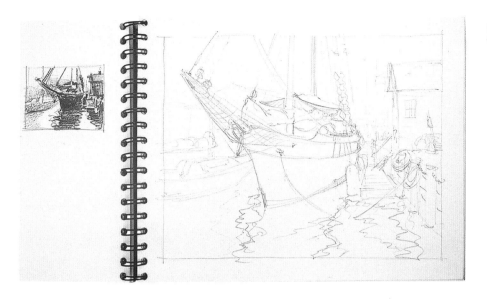

Paint Major Shapes

3 | Draw a rectangle to frame your water-color sketch. Draw the outlines of the major shapes and angles. Keep your thumbnail sketch close for reference.

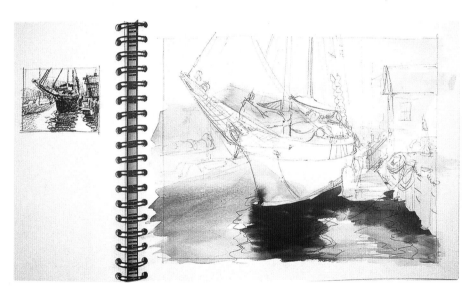

Apply Light Values

4 | Rather than filling in values with a pencil, use watercolors or watercolor pencils. You can use one color or a full palette, but make sure to concentrate on values and edges more than color choice. This emphasis will help during your final painting; you'll concentrate more on the values of each color than on replicating the colors in your sketch. Apply your light values first.

Tip Paint from light to dark and from background to foreground.

5 | Apply Midtones

Add midtones. You don't have to limit your midtones to just one value or color. Put down washes that cover as big an area as possible in each wash to keep it simple. Save the details for the final stage.

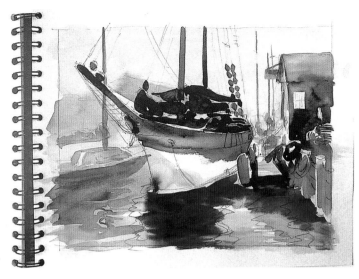

6 | Add Darks

Put in the darks and start adding details. Remember that your sketch doesn't have to be picture-perfect or a model of photorealism.

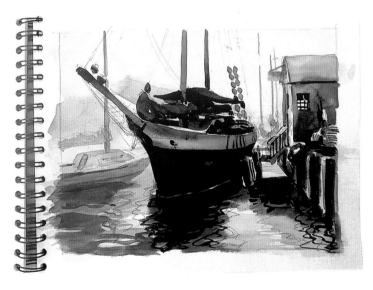

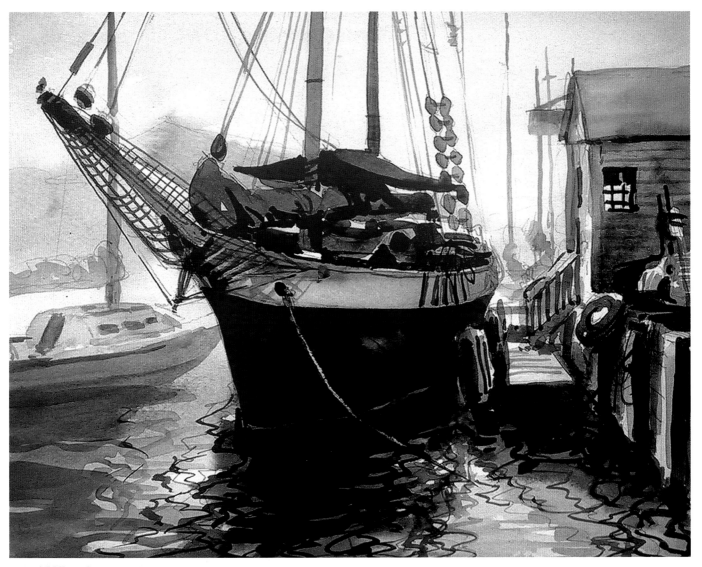

Add Details

7 Sketch in the rest of the details. This sketch should serve as practice and a blueprint for a more finished, larger painting.

NEWPORT DOCK • Watercolor in sketchbook • 8¹/₂" × 11" (22cm × 28cm)

Tip Apply what you've learned during the sketching process to your final painting. If the sketch looks good enough to be a painting, just think how good the painting will look!

Plein Air Sketching

Tip An overcast sky distributes the sun's light evenly, so the value pattern of your sketch or painting will follow the objects' local colors. If the scene is sunlit, as in the photo below, your value pattern should follow the sunlit areas.

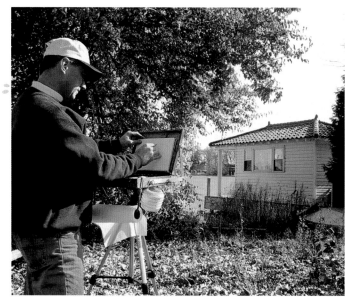

Doing a sketch away from the comforts of your studio may be a challenge, but the experience will last a lifetime.

1 | Establish Lighting
Establish the lighting and value pattern of the scene before starting your sketch. Light means everything to a painting; without it, you would have nothing but black.

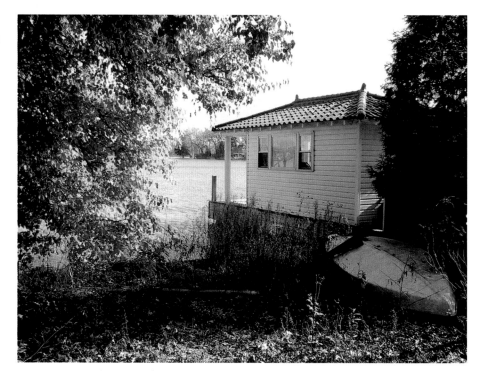

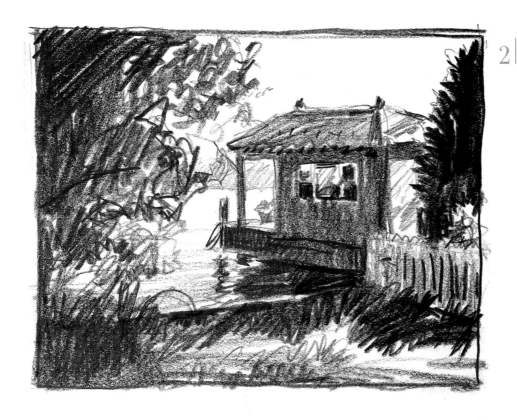

Draw Thumbnail

2 Do a fast thumbnail sketch. A full-blown value sketch takes too long for plein air sketching. Sketch as quickly as possible, capturing the scene before the light changes, which can happen quickly. For the rest of your sketch, stick with the lighting and value pattern you sketched in this thumbnail, even if the light has changed in the real scene in front of you.

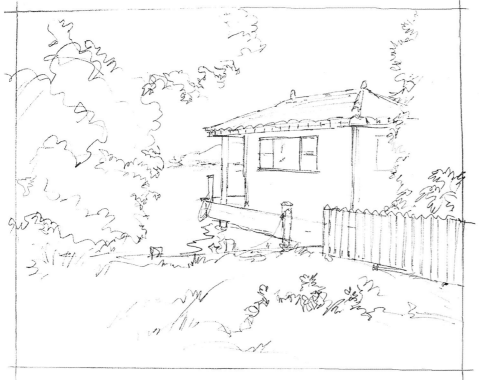

Draw Line Drawing

3 Draw a line drawing on your water-color paper. Keep it simple; time is a big factor, and you don't want to waste your whole day in the same spot.

Paint Sky

4 Because you should be working light to dark, you'll paint the sky with your first wash. Paint the sky wet-in-wet, starting at the top of the paper and working your way down.

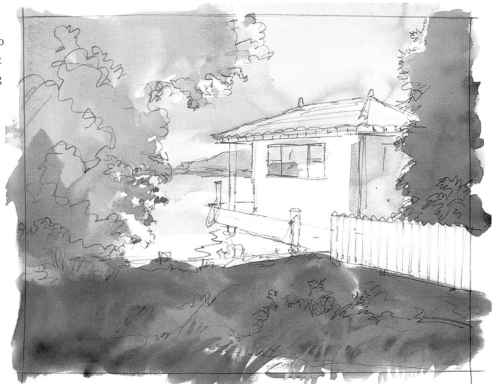

Add Midtones

5 Again, apply large washes of midtones with a second layer of washes. Carve out shapes and add as much dimension as possible.

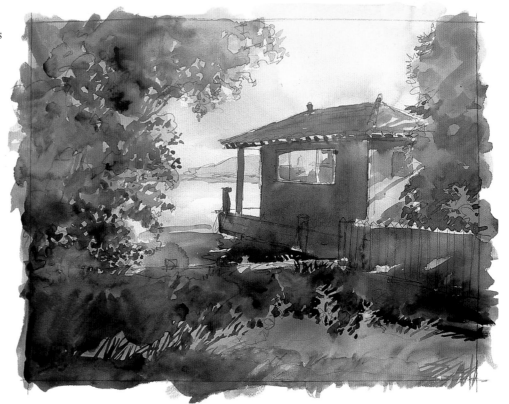

Tip Use the wet-in-wet technique when painting plein air. It allows plenty of time to work before the paint dries.

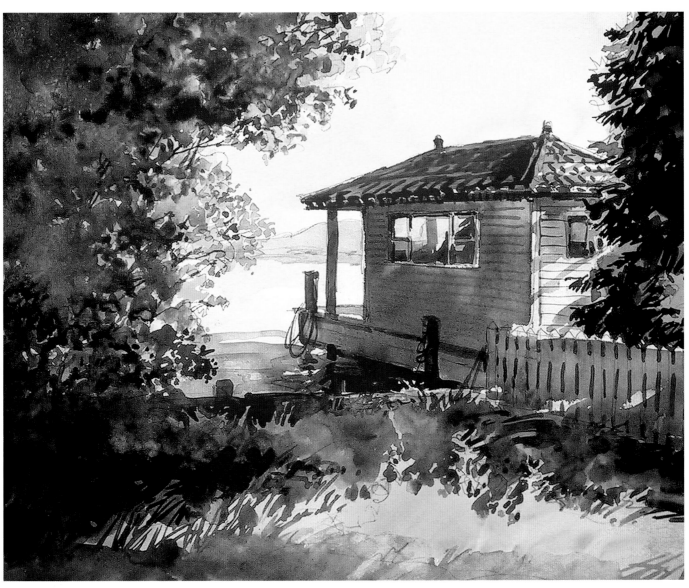

Add Darks and Details

6 | Lay down your darkest washes and add whatever accents you'd like.

SUSAN'S BOAT HOUSE • Watercolor on Strathmore 5-ply bristol board •
11" × 16" (28cm × 41cm)

Studio Sketching

1 **Use Your Artistic License**
A studio, with all its comforts, often is the best place to get things done. You can keep distractions at a minimum here. I took this photo in overcast weather. I added a bit of sunlight and a few puddles on the computer. I then printed the new image on a color printer. You also could paint from the image on the computer screen. If you don't have a computer, examine reference photos with the lighting conditions and lighting direction you want to use. Study how the light behaves and incorporate the new lighting in your value sketch.

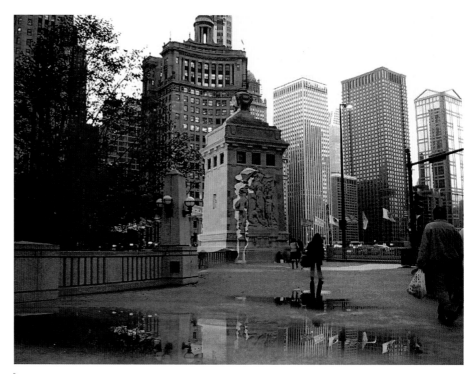

2 **Draw Value Sketch**
Draw a value sketch to establish the value pattern you want to use. Make sure you keep it simple.

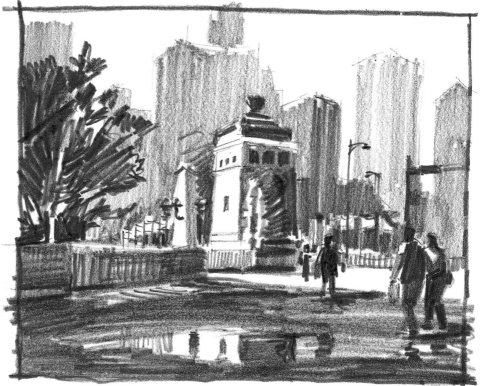

3 | Draw Sideline Sketch

Draw a sideline sketch to determine how you'll draw the details and values in the figures. These figures are important enough for a sideline sketch because they are part of the foreground and center of interest.

4 | Draw Line Drawing

Use an HB pencil to sketch base lines onto watercolor paper for your final painting. A pencil that is too soft will leave too much lead on the paper, which will make your washes dirty. A pencil that is too hard will leave grooves in the surface of the paper or lines that are so light they'll disappear with the first wash.

Tip If the line work looks like it has too much graphite, roll a kneaded rubber eraser into the shape of a rolling pin. Roll the eraser back and forth over the line. If you've picked up all of the loose graphite, the pigment will remain clean when you lay it down. This is especially important when applying a light wash.

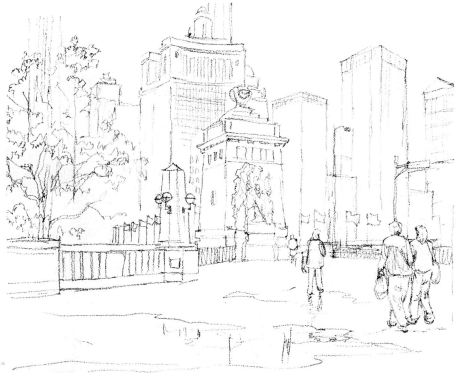

5 | **Apply Light Tones**
Apply light washes wet-in-wet over the large areas. Use plenty of pigment. Washes usually appear 20 percent lighter after they dry.

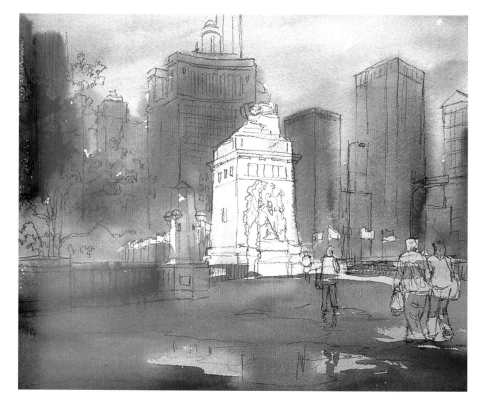

6 | **Apply Midtones**
Add midtones, carving out areas and objects. Paint the negative space around each object, creating its shape with the darker washes around it.

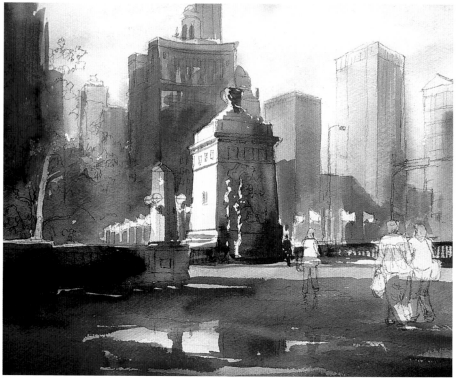

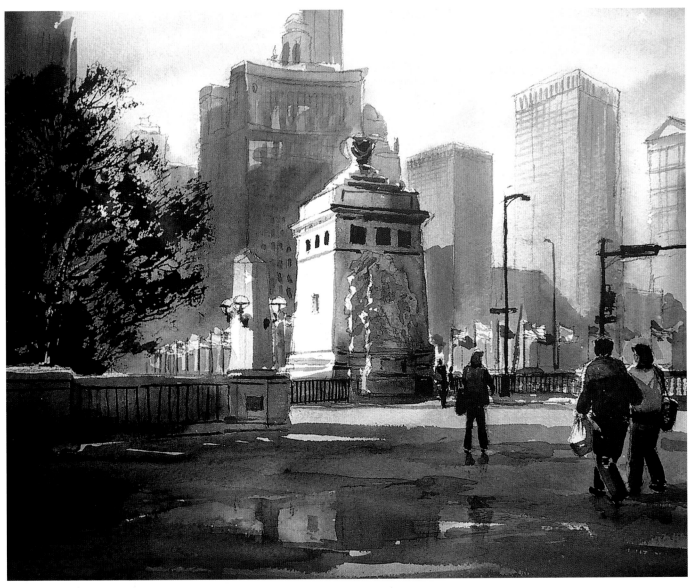

Add Details

7 Now add the fun stuff—details! The details added during the final stage are like frosting on a cake, small things that make a big difference. They make the painting look finished. Add the flags on the bridge and any small line work, such as the fence railing and the purse straps. Add the street signs, the street light and the shadow on the tree trunk to make the street and tree look more real. Also clean up any edges that may have gotten away from you by scrubbing with a clean brush and dabbing with a tissue during this stage. Add whatever other details matter to you. This stage differs for every artist.

WALKING TOWARD MICHIGAN AVENUE TOWERS • Watercolor on Arches 300-lb. (640gsm) rough • 13" × 16" (33cm × 41cm)

Conclusion

I'm a strong believer in practice and hard work as the means to achieve excellence in art. Listening to a lecture, reading books, buying the latest and greatest supplies, cleaning your studio, watching others give demonstrations, anything that doesn't include putting pencil, pen or brush to paper yourself, doesn't help as much as sitting down and sketching, drawing or painting. And don't just sketch now and then or once or twice a month. Make time to sketch often. The more you do, the better you'll get.

Many have told me they just don't have the time to dedicate to painting, and when they do find time, they want to get right into pushing the paint around, not sketching. But sketching can teach you things that will make the pushing paint around part more productive. You don't need to do a tight drawing, just a sketch to help you understand the elements, composition and procedures needed to create a finished work of art.

Sketches are plans of attack for paintings. Some artists can picture their plans in their heads, knowing what values go where and what colors to use. Practicing sketching can get you to that point. Other artists like to do a small, fast, black-and-white thumbnail sketch to get themselves going. Others need to go as far as planning the color scheme in a color value sketch. Do whatever it takes to get yourself sketching. All of it is, beyond anything else, good practice!

I did this sketch from my imagination. Sketching from your mind's eye is great practice. Just sit down and start drawing, sketching and painting anywhere, anytime. Practice every day. It's the secret to becoming a better painter. Happy sketching!

WAITING AT UNION STATION · Watercolor on Crescent cold-press watercolor board · 12" × 13" (31cm × 33cm)

Index

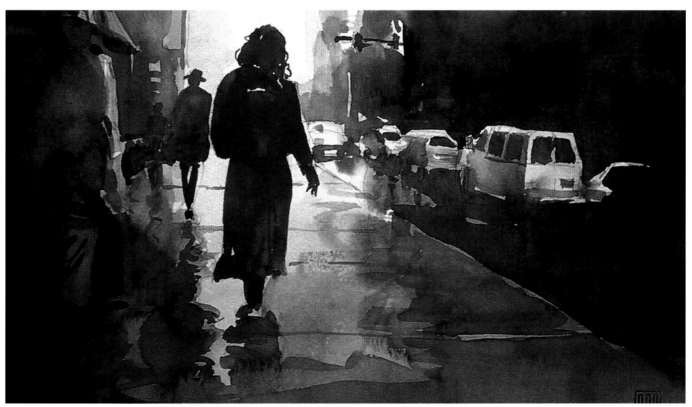

WALKING IN THE RAIN • Watercolor on Crescent cold-press watercolor board • 8" × 14" (20cm × 36cm) • Collection of Dayle Sazonoff

Here's more fun & easy art instruction from North Light Books!

Beautifully illustrated and superbly written, this wonderful guide is perfect for water-colorists of all skill levels! Gordon MacKenzie distills over thirty years of teaching experience into dozens of painting tricks and techniques that cover everything from key concepts, such as composition, color and value, to fine details, including washes, masking and more.

ISBN 0-89134-946-4, HARDCOVER, 144 PAGES, #31443-K

Create your own artist's journal and capture those fleeting moments of inspiration and beauty! Erin O'Toole's friendly, fun-to-read advice makes getting started easy. You'll learn how to observe and record what you see, compose images that come alive with color and movement, and make a travel kit for creating art anywhere, at any time.

ISBN 1-58180-170-X, HARDCOVER, 128 PAGES, #31921-K

Learn how to act upon your artistic inspirations and joyfully appreciate the creative process! This book shows you how to develop the skills you need to express yourself no matter what unusual approach your creations call for! Experiment with and explore your favorite medium through dozens of step-by-step mini demos.

ISBN 1-58180-102-5, HARDCOVER, 144 PAGES, #31790-K

No matter how little free time you have available for painting, this book gives you the confidence and skills to make the most of every second. Learn how to create simple finished paintings within sixty minutes, then attack more complex images by breaking them down into a series of "bite-sized" one-hour sessions. Includes 12 step-by-step demos!

ISBN 1-58180-035-5, PAPERBACK, 128 PAGES, #31800-K

These books and other fine North Light titles are available from your local art & craft retailer, bookstore and online supplier or by calling 1-800-448-0915.